Women Painting Women

Rita Ackermann
Njideka Akunyili Crosby
Emma Amos
María Berrío
Louise Bonnet
Lisa Brice
Joan Brown
Jordan Casteel
Somaya Critchlow
Kim Dingle
Marlene Dumas
Celeste Dupuy-Spencer
Nicole Eisenman
Tracey Emin
Natalie Frank

Hope Gangloff
Eunice Golden
Jenna Gribbon
Alex Heilbron
Ania Hobson
Luchita Hurtado
Chantal Joffe
Hayv Kahraman
Maria Lassnig
Christiane Lyons
Danielle Mckinney
Marilyn Minter
Alice Neel
Elizabeth Peyton
Paula Rego
Faith Ringgold

Deborah Roberts
Susan Rothenberg
Jenny Saville
Dana Schutz
Joan Semmel
Amy Sherald
Lorna Simpson
Arpita Singh
Sylvia Sleigh
Apolonia Sokol
May Stevens
Claire Tabouret
Mickalene Thomas
Nicola Tyson
Lisa Yuskavage

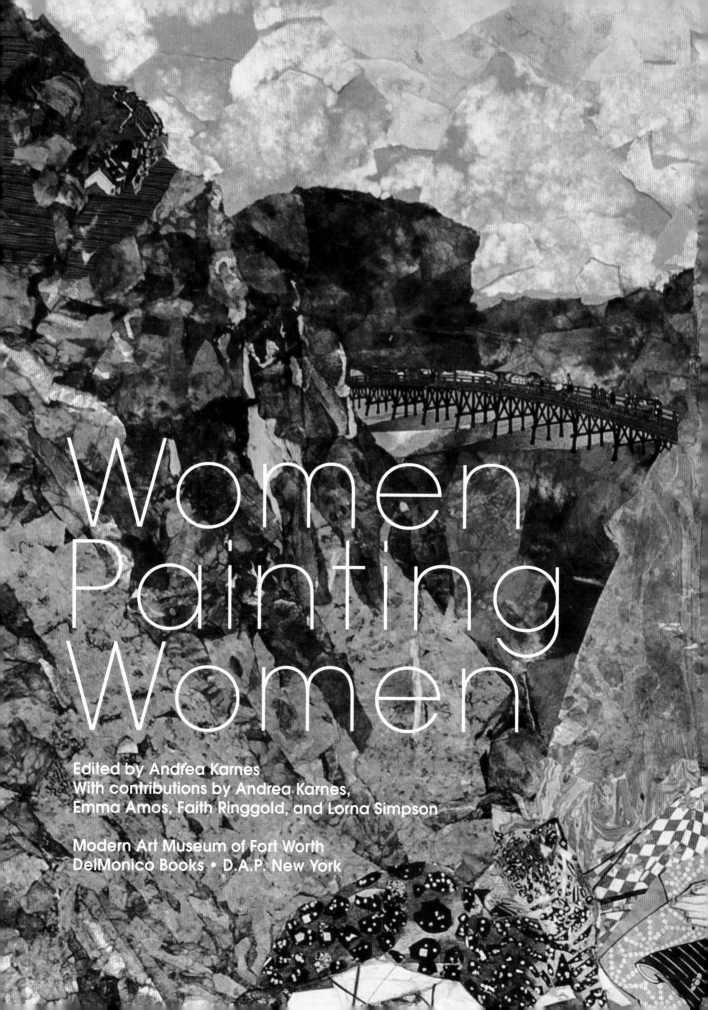

Women Painting Women

Edited by Andrea Karnes
With contributions by Andrea Karnes,
Emma Amos, Faith Ringgold, and Lorna Simpson

Modern Art Museum of Fort Worth
DelMonico Books • D.A.P. New York

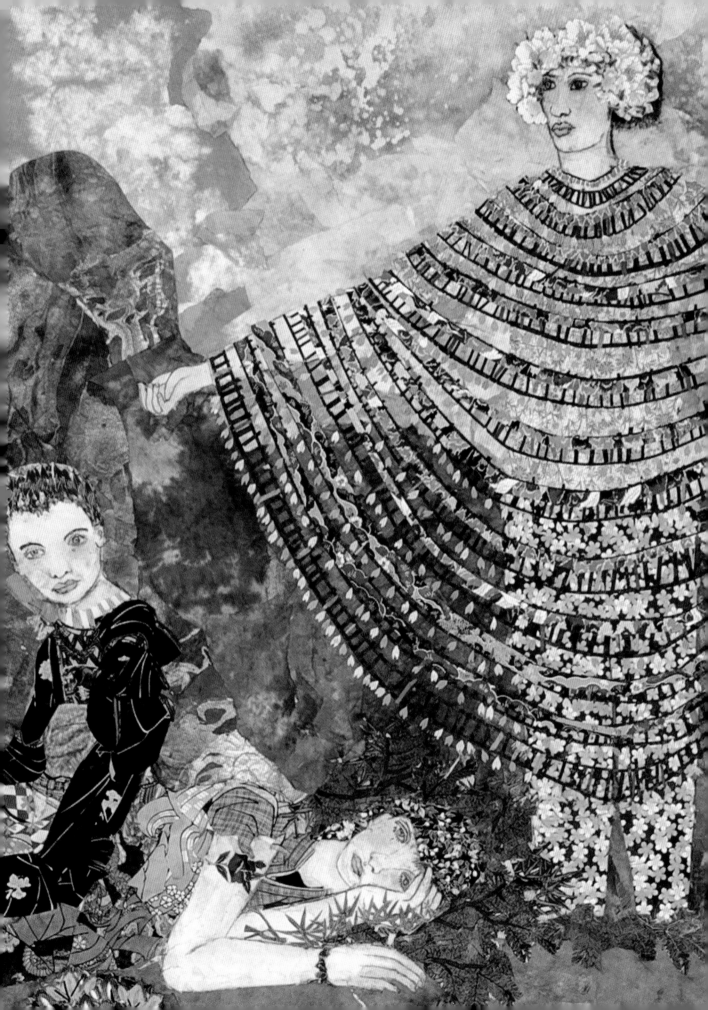

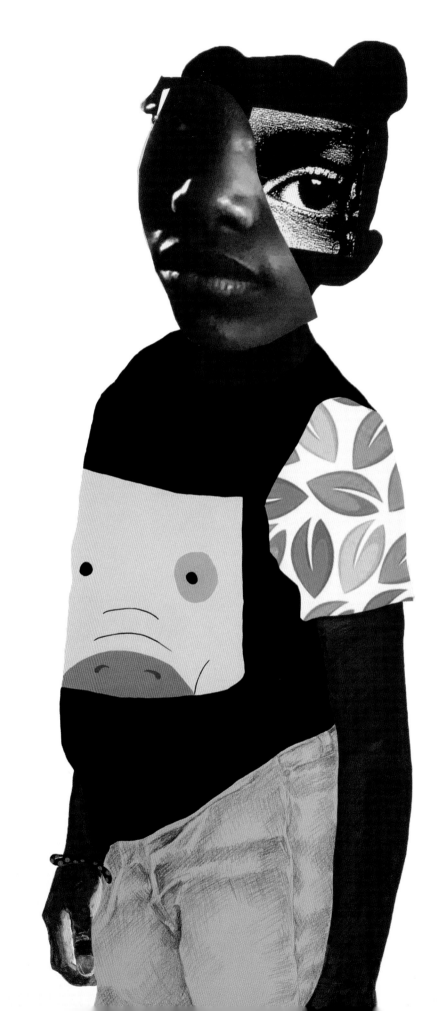

Contents

Catharina van Hemessen
Self-Portrait at the Easel, 1548

Oil on oak panel
12 ¾ × 10 inches
Kunstmuseum Basel, Gift of Prof. J.J. Bachofen-Burckhardt
Foundation 2015, Inv. 1361

Preface and Acknowledgments—

Catharina van Hemessen painted *Self-Portrait at the Easel* in 1548, the earliest surviving example of a now iconic composition showing the artist mid-brushstroke. When Lavinia Fontana created *Minerva Dressing* in 1613, she became the first woman artist to render the female nude. Through the eighteenth, nineteenth, and early twentieth centuries, painters like Élisabeth Vigée Le Brun, Mary Cassatt, Frida Kahlo, and many others portrayed female sitters and their experiences despite considerable obstacles facing women artists. *Women Painting Women* presents artists who continue this lineage, who have chosen paint as their material and women as their subject matter, in works from the late 1960s to the present. International in scope, the exhibition includes trailblazers like Alice Neel, Maria Lassnig, and Luchita Hurtado alongside contemporary emerging artists such as Jordan Casteel, Ania Hobson, and Apolonia Sokol.

The paintings in this exhibition reflect the artists' and the sitters' varied cultural backgrounds and life stories. Paint offers a particularly dynamic means of depicting skin tone, and the artists here deploy it with creativity and skill in intricate tapestries of color, explicitly and implicitly questioning historical racial categorizations. They work in styles ranging from semi-abstract to hyperreal, idealist to abject, expressionistic to hard-lined, surreal to geometric. A few of the women rely on friends and family as sitters, while others focus on strangers or look deep inside themselves. Regardless, the painters place their subjects' individuality at the forefront.

At the same time, all the artists draw on and challenge the canon of art history. The odalisque makes an appearance in several works to critique traditional practices of representation and the sexualization of women. The concept of the gaze surfaces repeatedly as the artists investigate the power implications of actively looking and passively being seen. Many works directly confront histories of objectification, domination, and marginalization. Iconography from folk and fairytales, popular culture, and pornography, references to traditional female arts such as quilting and embroidery, and frank depictions of menstruation, sex, and pregnancy speak to complex and frequently taboo female experiences.

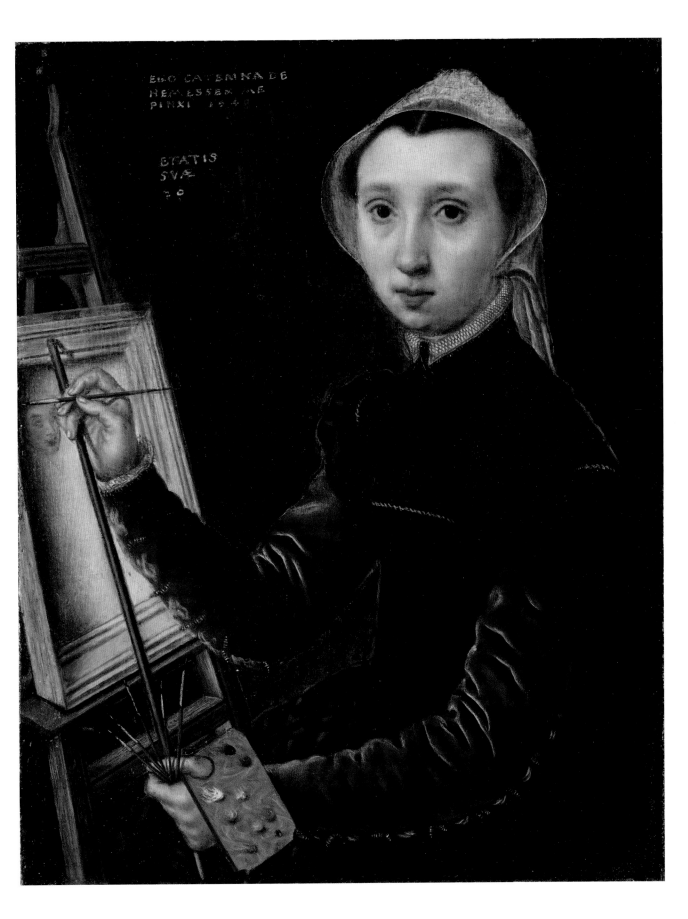

The artists' biographies register the myriad roadblocks encountered by women artists, including career interruptions and delayed recognition, especially in an era when painting was suspect and figurative painting even more so. Their life stories also encapsulate the measures they have taken to address institutional and cultural barriers: many of the artists are or were activists in civil rights, feminist, and LGBTQ causes. Both the biographies and the works in the exhibition attest to the fluidity of gender and other conceptions of identity.

The Modern's chief curator and organizer of *Women Painting Women*, Andrea Karnes, explores these issues and more in her essay for this catalogue, "A Vision in Many Forms." Other contributions add essential historical and insightful literary context, and I am grateful to their authors: Emma Amos (1937–2020) for the wry "Some Do's and Don'ts for Black Women Artists," first published in *Heresies* magazine in 1982; Faith Ringgold for the excerpt from "The 1970s: Is There a Woman's Art?," a chapter in her groundbreaking *We Flew over the Bridge: The Memoirs of Faith Ringgold*; Lorna Simpson, for her poem "We Have Been Whispering in Each Other's Ears for Centuries"; and S. Janelle Montgomery, curatorial assistant at the museum, for the artists' biographies.

I am especially appreciative to those whose generous funding made this exhibition and catalogue possible and who are listed on page 180. I also extend my gratitude to the lenders to the exhibition, who are acknowledged on the facing page, for sharing their treasures with us. I thank Andrea Karnes for her innovative vision that has brought us this and many other memorable exhibitions; curatorial assistant S. Janelle Montgomery, for her help on every aspect of this complex undertaking; Leslie Murrell, the museum's editor, for her dedication and patience; Derrick Saunders, graphic designer, for his creativity and perseverance in designing this book; and everyone at the Modern whose talents saw this project through.

On behalf of the staff and Board of the Museum, my special thanks to the artists and their representatives for their contributions to this exhibition. Nearly half a millennium since Catharina van Hemessen put her identity as a painter on display, the Modern Art Museum of Fort Worth is proud to organize *Women Painting Women*, bringing together key works by and about such a diverse group of women.

—Dr. Marla Price, Director

Lenders to the Exhibition

ACA Galleries, New York

Alturas Foundation, San Antonio, Texas

ARTAPAR LTD: The Tiqui Atencio Collection

Ivor Braka Ltd.

The Broad Art Foundation

Brooklyn Museum

Jordan Casteel

The Charles Collection

Sadie Coles HQ, London

Crystal Bridges Museum of American Art, Bentonville, Arkansas

Kim Dingle

Natalie Frank

Doree Friedman

Stephen Friedman Gallery, London

Eunice Golden

Green Family Art Foundation

Hauser & Wirth

The John and Susan Horseman Collection

Hort Family Collection

The Estate of Luchita Hurtado

Alvaro Jimenez Collection, London

Kiran Nadar Museum of Art (KNMA), New Delhi, India

RYAN LEE Gallery, New York

Christiane Lyons

Meliksetian | Briggs, Los Angeles

Nino Mier

Marilyn Minter

Modern Art Museum of Fort Worth

The Museum of Modern Art, New York

Nancy A. Nasher and David J. Haemisegger

Nerman Museum of Contemporary Art, Johnson County Community College, Overland Park, Kansas

Night Gallery, Los Angeles

Gina and Stuart Peterson

THE PILL®

The Rachofsky Collection

Claude Reich

Gloria and Howard Resin, Los Angeles

Steven Riskey and Barton Fassino

Deborah Roberts

Salon 94, New York

Ben Shenassafar

The David and Alfred Smart Museum of Art, The University of Chicago

Apolonia Sokol

Sperone Westwater, New York

The Estate of May Stevens

Claire Tabouret

Sharad and Mahinder Tak

Isabella Wolfson Townsley, London

Laura & Barry Townsley, London

Stephanie and Leon Vahn

Dean Valentine and Amy Adelson

Jennifer and Jon Weaver

and those lenders who wish to remain anonymous

A Vision in Many Forms—

by Andrea Karnes

Today, when the field of possibilities is so open, it could be easy to overlook that women artists have been underrepresented throughout the history of painting. This survey examines the powerful ways that female figurative painters from across the globe have used their medium for the last fifty years to overturn social stereotypes about women as subjects. The definition of "woman" is currently being contested and liberated from binary gender terms, and the implicit whiteness of maker, subject, and viewer is also being called into question, making the moment seem right to acknowledge an overarching narrative of how painting is and has been deployed by women artists as a vehicle for change.

The multigenerational nature of this exhibition, and its timespan from the late 1960s to now, helps illustrate key conversations that are still alive and making their way into imagery. The artists in *Women Painting Women* engage in analyzing gender, sexuality, identity, censorship, exile, community, and headspace, and sites that are public versus those that are private. There is also a conversation here about the women's movement of the 1960s and its complicated relationship with race (principally, how the movement foregrounded white women). With the interplay of these complex backdrops in mind, this presentation explores themes of Nature Personified, The Body, Color as Portrait, and Selfhood. It is important to note that the themes are meant to be a fluid framework and reflect the diversity of female voices engaged in painting female subjects. Any of the artists could easily be examined through more than one of the categories.

Art history and its tendency to omit women artists throughout its trajectory is a topic at the fore in many of these works. As Linda Nochlin argues in her groundbreaking essay "Why Have There Been No Great Women Artists?," which turned fifty in 2021, we have been conditioned, in viewing art, to normalize the white male viewpoint as if it were natural, especially when it comes to depictions of women.[1] Nochlin reframes the notion of genius to point out that race, gender, socialization, and education are factors, more often than not, that determine the emergence of "great" artists, and things have not historically been equal but instead skewed toward the elevation of white males. Nochlin explains that white male genius is not miraculous, but that "the miracle is, in fact, that given the overwhelming odds against women, or blacks, so many of both have managed to achieve so much sheer excellence, in those bailiwicks of white masculine prerogative like science, politics, or the arts."[2] With women artists often struggling to break through, painting is most associated with male interpretations of the female body.

Willem de Kooning
Woman I, 1950-52

Oil on canvas
75 × 58 inches
The Museum of Modern Art, New York; Purchase
© 2022 The Willem de Kooning Foundation /
Artists Rights Society (ARS), New York
Digital image © The Museum of Modern Art /
Licensed by Scala / Art Resource, NY

Portraiture places an intense focus on subjecthood and objecthood—positions that, respectively, denote the power of looking and the passivity of being looked at (viewer and sitter). The power historically aligns with man and the submissiveness with woman. From its publication in 1975, Laura Mulvey's definition of the (implicitly white) "male gaze" as it relates to (implicitly white) women in film has been applied broadly to the visual arts.[3] In 1992, the American author, professor, and feminist bell hooks gave voice to the dynamics of looking as it relates to Black people in "The Oppositional Gaze: Black Female Spectators." Bringing racialized power relations into the conversation and contextualizing her points by examining dominated children and slaves, hooks explains that repressing a returned gaze generates a yearning to look—a "rebellious desire"—and that the ability to manipulate a stare, or return a look, creates agency.[4] "Looking and looking back, black women involve ourselves in a process whereby we see our history as counter-memory, using it as a way to know the present and invent the future."[5] The male gaze (the "normalized" power position) sees the female figure specifically through the filter of male stereotypes, and this premise, laid out by Mulvey and expanded by hooks, is what challenged many of the women painters included in this survey. The experimental art of the 1960s and 1970s, especially conceptual and performance art, has been strongly associated with women artists, as have certain mediums such as photography; however, postwar painting has been emphatically aligned with white male artists. Subverting the traditional artist/model positions and bravely moving forward to expand representations of female sitters, the artists in *Women Painting Women* bare complexities, abjection, beauty, carnality, sexuality, intellectuality, spirituality, pain, and pleasure.

Willem de Kooning's paintings of women offer one striking postwar example, among many others, of the male gaze at work. They are arguably the most controversial of all his paintings and remain debated to this day. *Woman I*, 1950-52, illustrates his complicated relationship with the subject. Critics lauded the work for its innovation and for the artist's adept paint handling, with flawless passages from translucent to opaque. With the *Woman* series it launched, de Kooning was hailed as reinvigorating the female goddess, the Venus, the nude, or the idol, to paraphrase the artist's own description of the work.[6] At the same time, he was criticized for grotesque portrayals of the women, with violent slashes of black paint, clashing colors, and aggressive brushstrokes, and he was called misogynistic for painting demonic heads with antagonizing mouths awkwardly plunked onto deformed and exaggerated female physiques.

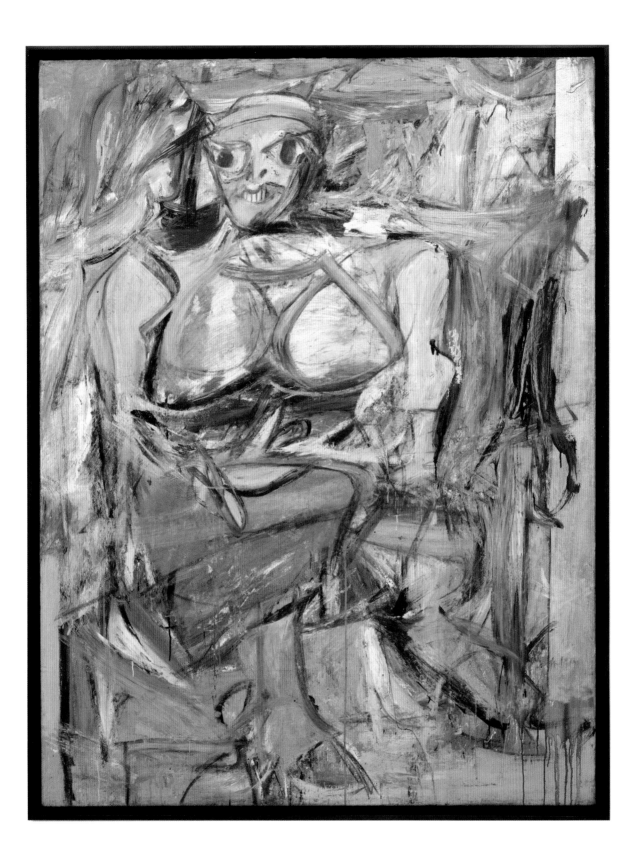

The complexity of de Kooning's women was matched by the complexity of women artists such as Alice Neel, who began painting nontraditional female nudes in the late 1920s, at the same time de Kooning's career began. As a woman, however, Neel remained off the radar of the art world for decades to come. An already successful man, like de Kooning, was the only type of artist allowed the freedom to publicly break the mold of tradition. At least partially because of the patriarchy at play, de Kooning's women became the signpost for postwar innovation. And though controversial, it was ironically his stirring of the pot with unconventional depictions of women that opened up possibilities for interpretations of the female form in paintings. With *Woman I*, de Kooning proposes for all future painters that images of women can be more than just one thing.

In the wake of de Kooning, early female pioneers of figuration such as Neel, Emma Amos, Faith Ringgold, and Sylvia Sleigh paved their own way, even as the art world was declaring painting to be, at worst, dead and, at best, only valid if abstract. As representation began a resurgence toward the close of the 1970s, Marlene Dumas, Marilyn Minter, Susan Rothenberg, and Lorna Simpson came onto the scene (at the time, Simpson was working in photography and mixed media, coming to painting later in her career). In the 1990s, personal and archetypal identity was probed by painters such as Nicole Eisenman, Tracey Emin, Jenny Saville, and Lisa Yuskavage. From the 2000s to the present, topics related to hybridity in womanhood based on postcolonial culture—explored by such artists as Njideka Akunyili Crosby, María Berrío, and Hayv Kahraman—or based on gender and sexual orientation—as seen in the works of Celeste Dupuy-Spencer, Jenna Gribbon, and Apolonia Sokol—have dominated the image of woman. Throughout this survey, the artists included look both to the concept and the reality of "woman" as subject matter for their paintings, and each questions, reinvents, and reinvigorates the identities de Kooning attributed to woman: the exalted or debased nude, the female goddess or monster, the multivalent idol.

Nature Personified explores female empowerment, relating anatomy to landscape and using the body as metaphor.

Eunice Golden
Crucifixion #1, **1969**

Oil on canvas
48 × 72 inches
Collection of Eunice Golden
© Eunice Golden

The artists featured in Nature Personified look to the mythology of womanhood—mother earth figures, priestesses, and goddesses—as well as to the metaphysical powers associated with being female. Historically nature has been represented as a woman, and this extends to women as symbolic of earth, including their objectified bodies. Eunice Golden, Joan Semmel, and Luchita Hurtado investigate woman as landscape to connect to that tradition of the female form as earth; Susan Rothenberg and Tracey Emin present women as elemental, autonomous beings, outside the nucleus of family; and María Berrío and Hayv Kahraman relate women to the supernatural to explore postcolonial culture and migration.

Golden, Semmel, and Hurtado are each represented with works from around 1970, and each came to figuration through abstraction. With similar concerns about reclaiming space for women, and with ties to the women's movement, the three artists depict the body in intimate, personal poses.

As Golden wrote in 1981, in "The Male Nude in Women's Art: Dialectics of a Feminist Iconography": "I needed imagery that permitted me to explore what I was feeling as a woman and as an artist."[7] Best known for her erotic paintings of male nudes in which she uses their bodies to evoke a landscape, Golden has investigated sexuality and female desire throughout her career, turning the gaze from females to males and upending the traditional artist/model relationship for her subjects and viewers. Golden has a rich history of being politically involved in feminism and with issues of censorship. In 1971, she joined Women's Art, spearheaded by the writer Lucy Lippard, and in 1973, the Fight Censorship group; and she was a founder of the women's co-op gallery SOHO 20 in New York City, where her work was exhibited for nearly a decade.

Golden said:

> *For women to take control of their own image-making processes, they must become aware of the dialectics of eroticism and power and why such imagery is taboo—especially potent phallic imagery like the erect penis. It is important for women to reclaim their sexuality, free from male precepts, and find their own imagery, their own awareness of themselves, and not only from an autoerotic or narcissistic point of view. There should be a place in women's art where intimacy can be defined in terms that are very broadly sexual: a prophetic art whose richness of fantasy may unleash a healthy appetite for a greater sense (of) awareness as well as unmask the fallacies of male power.[8]*

Crucifixion #1, 1969, is considered the antidote to Golden's male landscapes. It portrays a female nailed to a cross, and as with her portrayals of men, here human form—the woman's belly, bare breasts, and arms—translates into a stretched-out view of an earthly terrain. A penis penetrates the body's left side, evoking the piercing of Jesus near the heart. The position of the body, outstretched and supine, also implies rapture, relating female pleasure to ecstasy in Christianity and the long history of depictions of this spiritual, internal awakening, seen in such works as Bernini's sculptural masterpiece *Ecstasy of Saint Teresa*, 1647–52, that meld religion with sensuality.

Much like Golden, Joan Semmel worked within an erotic visual language that related anatomy to a landscape, while exploring female desire and challenging the male gaze. The results are large-scale works that suggest her expressionistic background, showing gestural, fluid figures in explicit sexual embraces. Upon returning to New York City in 1970, after living in Spain where she made abstract paintings for several years, Semmel wanted to become involved in the women's movement. "I had returned from Spain looking for the sexual revolution and instead found sexual commercialization that mostly showed female bodies for sale. I wanted to find an erotic visual language that would speak to women. I was convinced that the repression of women began in the sexual arena, and this would need to be addressed at the source."[9] As she moved out of abstraction into figuration and began to make erotic pictures of women's and men's intertwined bodies, Semmel found her voice and initiated her series *Sex Paintings*, to which *Untitled*, 1971, belongs. In the paintings, heterosexual couples' bodies become one in scenes that evoke nature through biomorphic, yet human forms.

The vibrant palette of the *Sex Paintings* diverges from nature, yet the organic treatment of bodies can be viewed on a macro level as the earth, or a landscape, or on a micro level, like living organisms observed under a microscope. The images give agency to women, especially because the close-up, foreshortened, and contorted source photographs reveal a view the artist could only get by working from her own body, making her both artist and model. The *Sex Paintings* elucidate sexual pleasure from a woman's perspective, and as with Golden's paintings, were as revolutionary in 1971 as they are today.

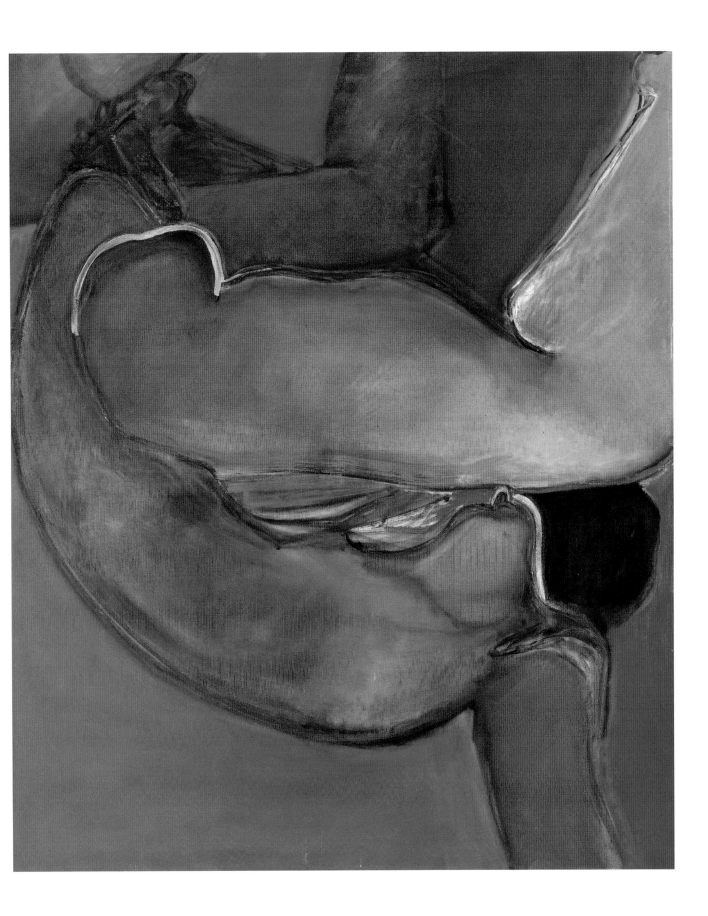

Luchita Hurtado
Untitled, 1970
Oil on canvas
30 × 50 inches
Courtesy The Estate of Luchita Hurtado
and Hauser & Wirth
© The Estate of Luchita Hurtado
Photo: Jeff McLane

Like Semmel, Luchita Hurtado paints her own body as landscape. Foreshortened, her legs, arms, breasts, and belly are rendered from her point of view, looking down. Sometimes she sets these body terrains against blue skies or boldly patterned tapestries, as is the case in *Untitled*, 1970, which shows two figures flanking a bright red, white, and black rug beneath their feet. While the colors convey a mood and a domestic environ, the bodies have the peaks and valleys of Hurtado's body-into-landscape paintings of the same decade, the *I Am* series. The works relate to mysticism and to the Surrealism of Leonora Carrington, Frida Kahlo, and others in the broad social circle that Hurtado

was part of. Like Semmel during this period, Hurtado moves fluidly from abstraction to figuration, with exaggerated bodily forms and patterns found in nature. Both artists often present us with a perspective that can only be described or understood as a first-person view—a woman's view. They each also suggest the idea that my body is my (the) world. Golden, Semmel, and Hurtado were active when Mulvey's text on the male gaze first circulated, and their works offer a countering response—the female gaze.

Although generations apart and stylistically different, Susan Rothenberg's *Mary III*, 1974, and Tracey Emin's *But you never wanted me*, 2018, both depict female figures that are primal and elemental in form, color, and composition. Rothenberg's work was made the same year the artist began painting the horses that would become her most emblematic image: singular, monochromatic, and at the center of the composition, much like her treatment of *Mary III*. Experimenting with ideas of animal/human and of stillness/motion, Rothenberg took Polaroid pictures of her friend Mary Woronov, an actress and one of Andy Warhol's superstars, bent over, with arms downward and outstretched. With these poses, Rothenberg was using the female figure to emulate the power and might of a horse, and from the photographs came the painting *Mary III*, which shows a woman in what looks like the moment before she begins to leap or gallop forward. Shortly after painting *Mary III*, Rothenberg flipped her idea and began using the horse as a surrogate for the female figure, but in this early work, Mary is animal and gestural. Earthen sienna, a color characteristic of the artist's work, dominates the painting and relates to the earliest images of horses: the cave paintings in Lascaux, France.

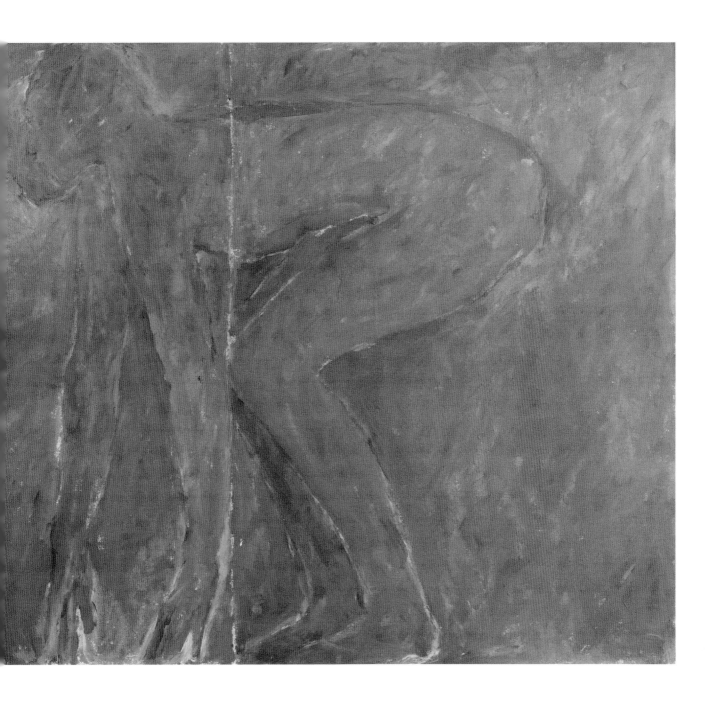

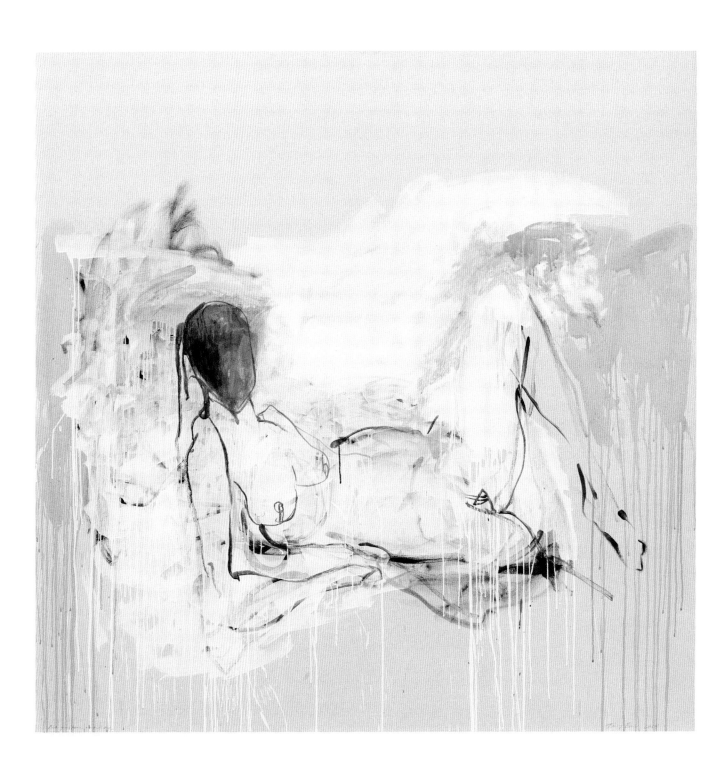

Tracey Emin
But you never wanted me, **2018**
Acrylic on canvas
71 ⅞ × 71 ⅞ inches
Collection of Gina and Stuart Peterson
© The Arist
Photo © White Cube (Theo Christelis) Courtesy White Cube

Although Tracey Emin's *But you never wanted me* was painted nearly forty-five years later, there is a kinship with *Mary III* grounded in the raw energy of intuition, expressiveness of paint, and immediacy of both form and content. Emin's painting communicates visceral emotion, emerging from a deeply personal place of loss, anger, sorrow, and love. This work belongs to a series of gestural works, unofficially referred to as the "period paintings," in which the female figure is seen reclining, sleeping, engaged in autoeroticism, or bleeding. The women in these scenes are made primarily with a palette of earthen red, pink, white, and black, with lines ranging from lyrical to scribbled and with washes and pools of color that drip down to the lower edge of the canvas. Although clearly representations of the body, the abstract passages and palette merge the figure with sky and ground in a rudimentary way, linking Emin's simplified yet potent images of women to nature. Trauma and passion both seep through in the image and title of *But you never wanted me*, and the loosely painted female body achieves the psychological intensity and confessional sensibility that Emin's work is known for.

While Golden, Semmel, and Hurtado abstract the female form, Rothenberg and Emin strip it to essentials at the same time as they produce a full view of the power of woman. Rothenberg likens the woman to a wild horse—a symbol of strength and power. Mary, crouching, suggests a prehistoric figure, and the clay color evokes a cave—the painting projects the dawning of woman. Emin's woman expresses a different type of primordial behavior that is emotional rather than physical. Self-soothing, she is sitting with her pain.

María Berrío and Hayv Kahraman use a symbolic visual language to address issues regarding postcolonial (Berrío) and non-Western (Kahraman) imperialism. They float between the themes of Nature Personified, Selfhood, and The Body, in that each employs her own mythology to probe the complexities confronting immigrants, especially in forming personal identity. Their images of superhuman women also explore how the body, especially as seen through the lens of colonialism, is an exoticized site.

The tactile and colorful collage on canvas *Wildflowers*, 2017, by María Berrío, depicts an allegory for humanity's integration with, not domination over, nature, and also presents the idea of glorifying women during crises of migration, deportation, and transition. It shows a train car and utility pole in an otherwise rural landscape, where women, children, and animals have come together. The woman in a shawl atop the train was inspired by the Incan god Urcuchillay, a herder deity who watches over animals. Berrío extends the care to refugees.[10] Wildflowers spring from all areas of the composition, including the women's and children's hair and bodies, in a way that suggest homeostasis—the physiological dependency of humans on nature. The central character is Madonna, from Christian iconography, who rejects the closure that death signifies and invites us to discover the promise of new life. The regeneration of nature (the wildflowers) reinforces this allegory.[11] Berrío's Colombian heritage comes into play, especially in terms of folklore and myth, as the women in her work are often portrayed as priestesses. The painting's harmony is interrupted by hints of industrialization, symbolizing our drive to control the world we inhabit. The train car in particular points to the immigration crisis, driven by a desire to control borders and lands that belong to mother earth, not her human inhabitants. Tigers, monkeys, birds, and others populate *Wildflowers*, and like Rothenberg's *Mary III*, which depicts a woman-as-horse, Berrío's work proposes equivalency between species—yet the women convey a goddess-like power.

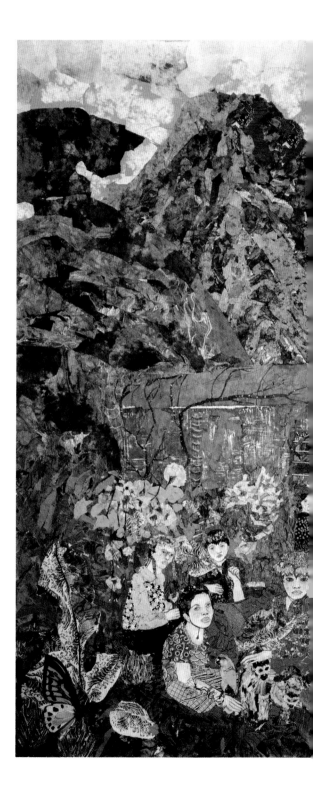

María Berrío
Wildflowers, **2017**
Mixed media
96 x 140 inches
Nancy A. Nasher and David J. Haemiseggar Collection
© María Berrío, Courtesy the Artist and Victoria Miro

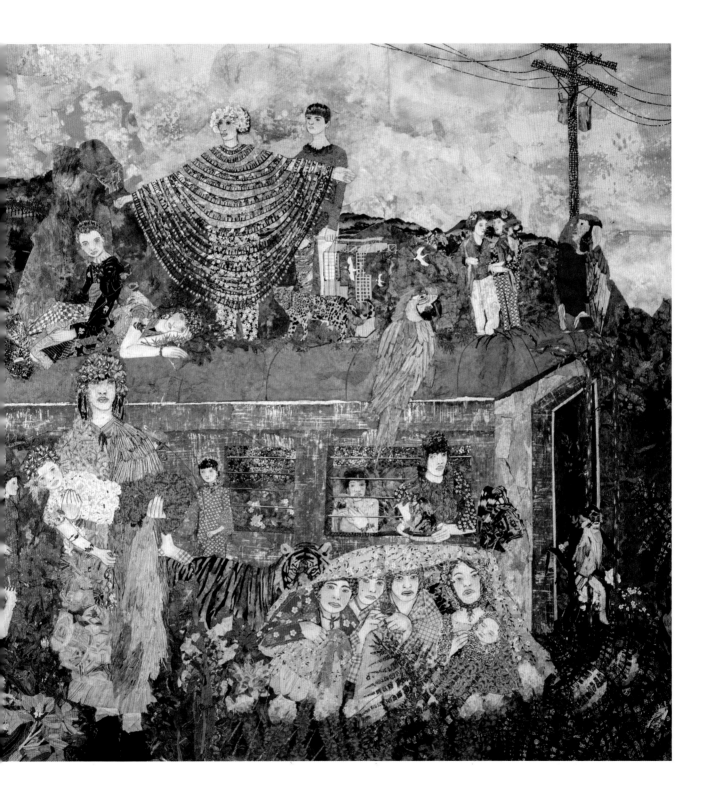

Hayv Kahraman
The Tower, 2019
Oil on linen
104 ⅛ × 79 ⅛ inches
The Rachofsky Collection
© Hayv Kahraman
Image courtesy of the Artist and
Jack Shainman Gallery, New York

The women Hayv Kahraman depicts in paintings, like Berrío's women, exist somewhere between humanness and otherworldliness. As a preteen in the 1990s, Kahraman (Iraqi-born, of Kurdish descent) fled Baghdad with her family, first to Sweden and then to Los Angeles, where she currently lives. Her work, which includes sculpture, performance, and painting, explores gender politics and the immigrant experience. For Kahraman, duplicated features on her figures allow them to represent a collective, non-white woman, in part to address exotic otherness but also to "uncover various injustices placed by normative ways of living in this world."[12]

Displacement, as it relates to diasporic people and to Kahraman herself, is explored in her images of women. "I don't see them as fully autobiographical. If anything, I'd say that there is an undeniable pinch of autoethnography in the figures that I don't shy away from. I don't think it's possible for me to make work that doesn't directly or indirectly navigate my own experience as an Iraqi woman refugee. There's an inevitable link that I feel needs to be unpacked and brought to the forefront."[13]

Characteristic of Kahraman's painting, *The Tower*, 2019, depicts a stack of repeating—yet slightly individualized through pose and features—women acrobats wearing leotards. The contorting bodies defy natural postures and multiply, manifesting displacement and dislocation. Their depictions relate to the dichotomy of resistance (seen in unnatural poses) and conformity (their replication), and of mentally inhabiting two places at once (their mirroring). The women are seductive, striking beauties, each with almond eyes, tangerine lips, unibrows, and a shock of ebony hair. There is an uncomfortable balance here between beauty and eroticism and the long history of dehumanizing and fetishizing the other. Their postures metaphorically point to bending over backwards, or the impossibilities faced by migrant women who are outside of the white Western archetype. On one hand, they express corporeality, with pubic hair accidentally exposed. On the other hand, they inhabit a metaphysical zone that connects them to spiritual transcendence. The repetitive women underscore the notion of regeneration, or fruitful mothers, a symbol used in many cultures that grounds them to earthliness. Flawlessly performing acrobatics with perfect geometry and symmetry, they do things that most real women cannot do. They are goddesses, powerful and capable of holding up under the weight of themselves.

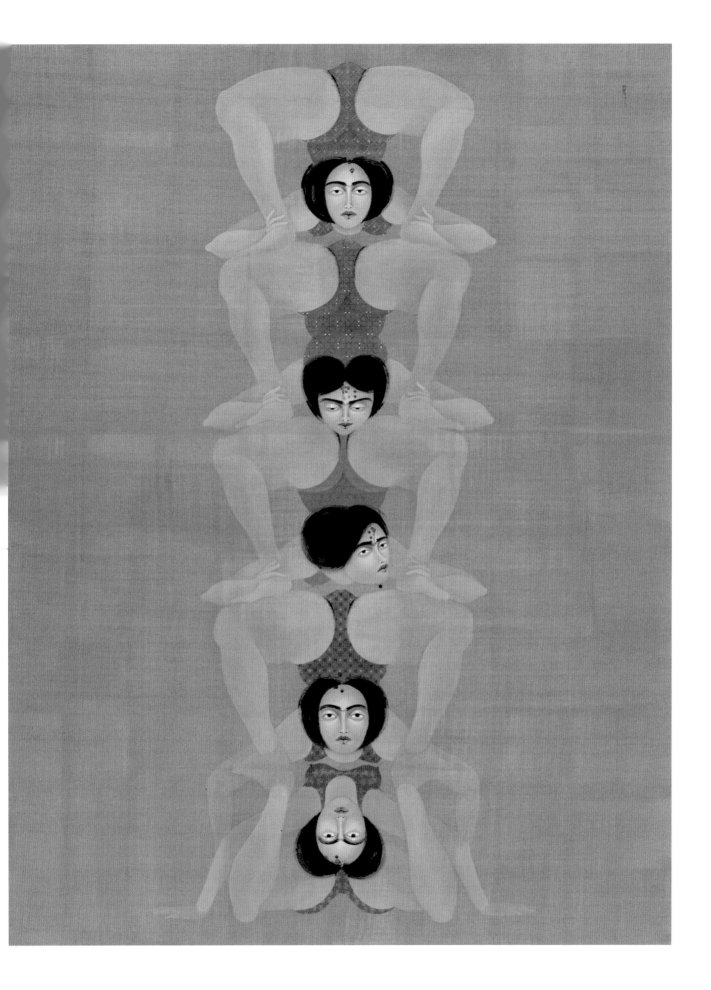

Natalie Frank
Couple I, 2021 (detail)
Mixed media
168 × 288 inches
Natalie Frank
© Natalie Frank
Photo: Farzad Owrang

The Body as a theme collapses centuries of portrayals of female nudes with varying new interpretations, examining the spectrum of approaches from unidealized to fantasized.

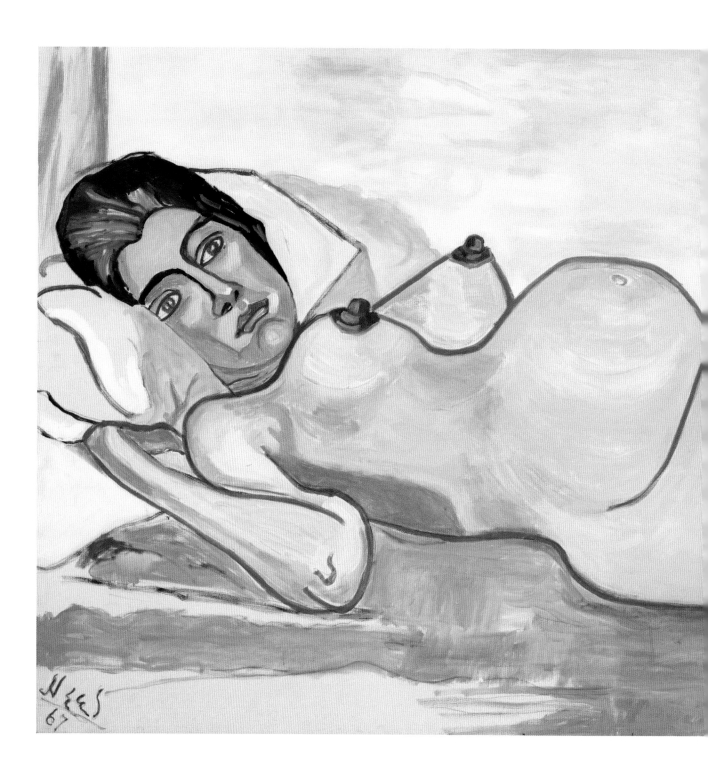

Alice Neel
Pregnant Nude, 1967
Oil on canvas
33 × 53 ⅞ inches
Private Collection, New York
© The Estate of Alice Neel,
Courtesy The Estate of Alice Neel and David Zwirner

From the Middle Ages to the pre-Renaissance era in Western art, naked bodies were depicted in religious scenes to symbolize vulnerability, fallibility, and sin. During the Renaissance, nude women (and men) became idealized and at times divorced from religious meaning, as in Sandro Botticelli's *The Birth of Venus*, 1485. The periods that followed, such as Mannerism and Rococo, introduced eroticism, and the Romantic period allowed for realism—Gustave Courbet's *The Origin of the World*, 1866, for example, shows a close-up of a woman's vagina, her head and limbs cropped from the image. By the nineteenth century, artists such as Paul Cézanne and Édouard Manet presented the female nude in varying classes of contemporary life, portraying modern women ranging from leisure seekers to prostitutes. Since then, idealism has morphed into eroticism, realism, and abjection. The artists explored within the theme of The Body boldly probe the female nude.

Chantal Joffe
Self-Portrait Naked with My Mother II, **2020**
Oil on board
95 ⅝ × 71 ½ inches
Private Collection
© Chantal Joffe, Courtesy the Artist and Victoria Miro
Image courtesy the Artist and Victoria Miro

Alice Neel, Chantal Joffe, and Jenny Saville are discussed in this theme for their treatment of the flesh—outwardness—for what it can express about inwardness. Lisa Yuskavage, Rita Ackermann, Marilyn Minter, Somaya Critchlow, Lisa Brice, and Natalie Frank disrupt the classic erotic female nude. Sylvia Sleigh and Mickalene Thomas channel history and the odalisque to investigate gender and race. Celeste Dupuy-Spencer, Jenna Gribbon, and Apolonia Sokol explore queerness, specifically sexuality and femme identity.

Unidealized portraits that have a psychological resonance characterize images of the female body by Neel, Joffe, and Saville. The women painted by Neel convey individuality and realness, ironically through the artist's generalizing of flesh and form. *Pregnant Nude*, 1967, shows Neel's characteristic tendency to streamline the body and break the rules of painting by contouring the figure with an unnatural blue outline. The naked sitter is Nancy, Neel's daughter-in-law, pregnant with her first child, and she is depicted awkwardly posed lying on a bed. Her flesh pools and flattens into her buttocks while her legs spread apart, seemingly to balance the weight of her hugely pregnant belly. Neel portrays the woman in a less-than-flattering moment and with an edge of anxiety, implied by her stiffened mouth and eyes that create a blank expression, and by how rigidly her head and neck lie on the pillow. Using such basic information, this frank portrait depicts what is clearly an uncomfortable pregnant woman. Like a traditional nude, she is recumbent with a passive gaze, yet her realness is too profound to subsist in the zone of male objectification.

In *Self-Portrait Naked with My Mother II*, 2020, Chantal Joffe paints herself naked sitting alongside her mother, who is clothed. As in Neel's *Pregnant Nude*, the women bear passive, neutral gazes, and the treatment of flesh includes a range of unexpected colors. In the face of Joffe's mother, for example, greens, reds, yellows, white, and black are used in ways that are more pronounced than realism would allow, and the skin and physiques of the women are also simplified. There is a superficial truth here, in that real skin absorbs and reflects light; and there is a deeper truth in the psychological mood of the work that is conveyed through generalized forms. The seeming contradictions come together to give a strong picture of the complexities of family and an awkward or uncomfortable mother/daughter dynamic. The mother leans away from the naked daughter and frowns, and their gazes go in different directions. The vulnerability of being a middle-aged naked woman sitting next your own clothed mother is matched by the fragility of the aging mother. There is a certain compassion about the image but also a brutality in the imperfections of the women. This work, like many in the exhibition, could easily belong to more than one theme—it is undeniably about using the body in a way that turns against the traditional male gaze; but it is also more than an outward treatment of flesh. It intensely reflects the sitters' states of mind.

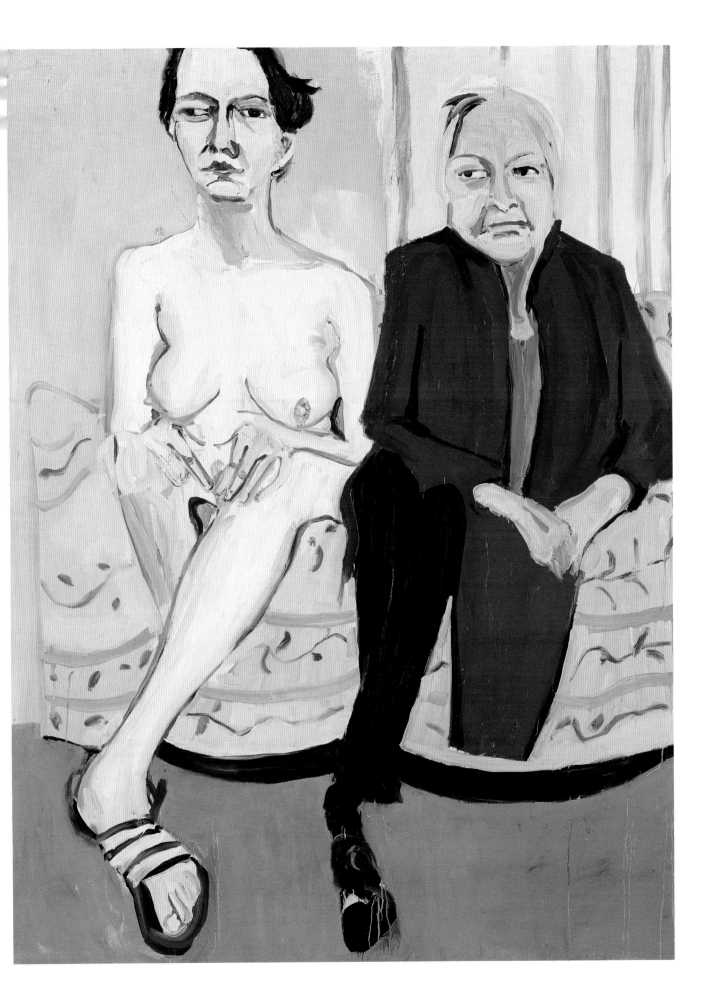

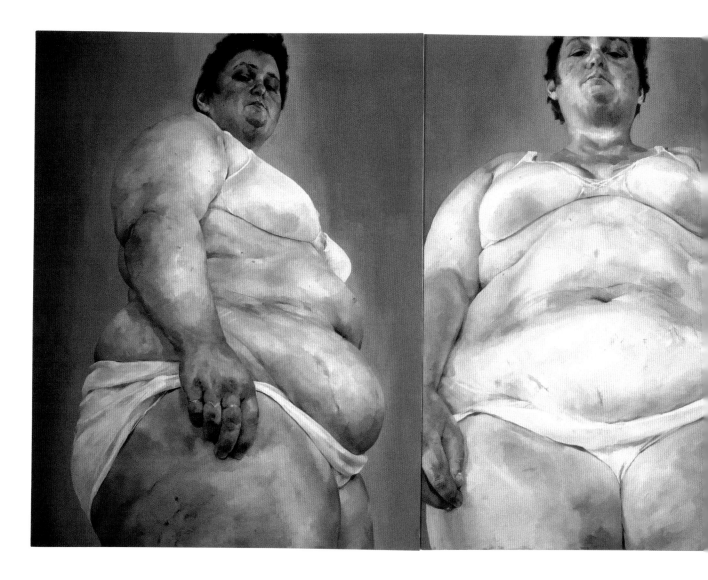

Whereas Neel and Joffe stylize form to induce a psychological read, Jenny Saville gets to the essence of womanhood through the body in such a way that her work *Strategy (North Face, Front Face, South Face)*, 1994, could be described as a portrait of flesh. The title refers to the directions the body faces in the three poses. The close-cropped, large-scale nature of the figure overwhelms, but the relaxed expression of the sitter counterbalances what could be perceived as a domination of flesh. Her eyes, though downcast, are not passive—she is looking down at the viewer, tracking us looking at her. The juxtaposition of face and body create an interiority and an exteriority together. As imposing as the image can seem, there is a soft, contoured beauty and a glance that projects vulnerability. Undoubtedly Saville is in dialogue with the loaded history of her white male artistic predecessors, from Titian and Peter Paul Rubens to Pablo Picasso, Lucian Freud, and de Kooning, who use physicality in

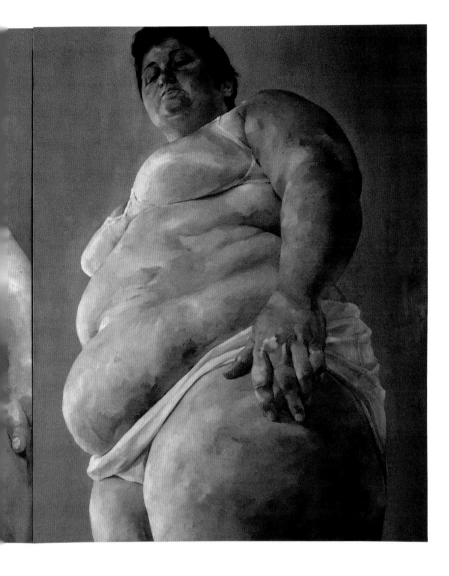

Jenny Saville
*Strategy (North Face, Front Face,
South Face)*, **1994**
Oil on canvas
108 × 251 ¹/₂ inches
The Broad Art Foundation, Los Angeles
© 2022 Artists Rights Society (ARS),
New York / DACS, London

varying ways to render their figures. Rubens, for example, is known for portraying voluptuous nude women with soft and sagging skin, yet the overall form is idealized; Freud's passages of pooling flesh are often described as truthful and drained of idealism. *Strategy* demonstrates Saville's ability to show the breadth of what paint can do. With detailed description of volume, heft, and texture, the artist proposes that the female image is complex while she also challenges beauty ideals.

Unlike Neel, Joffe, and Saville, Lisa Yuskavage, Rita Ackermann, Marilyn Minter, Somaya Critchlow, and Lisa Brice use the established language of fantasy, eroticism, and objectification to draw us in, but at the same time, they each disrupt tradition. Natalie Frank also uses a sexualized language, but one that more overtly upsets eroticism to create a psychosexual portrait of woman.

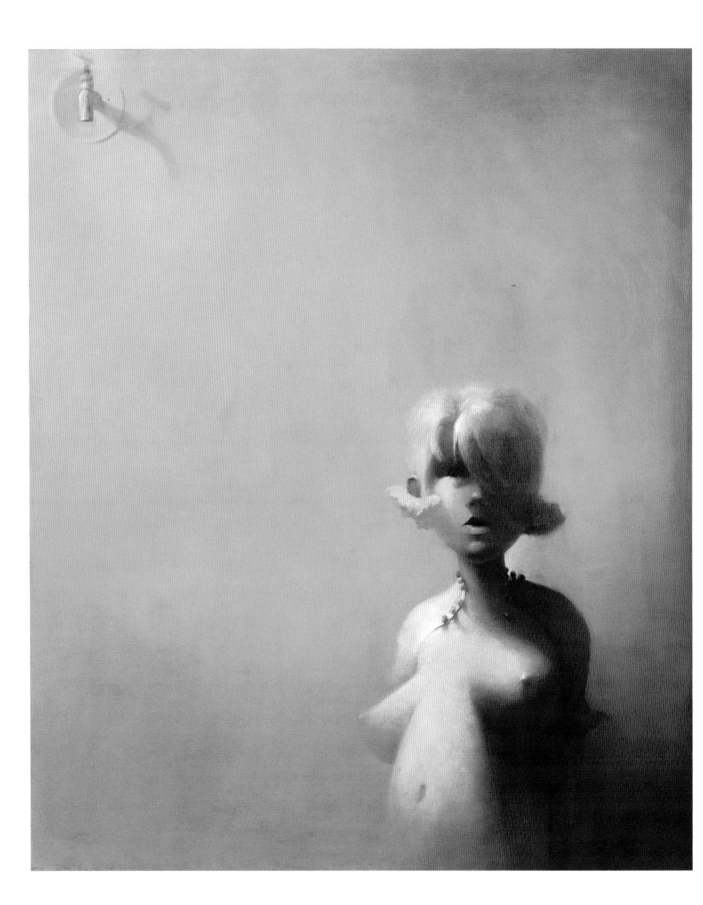

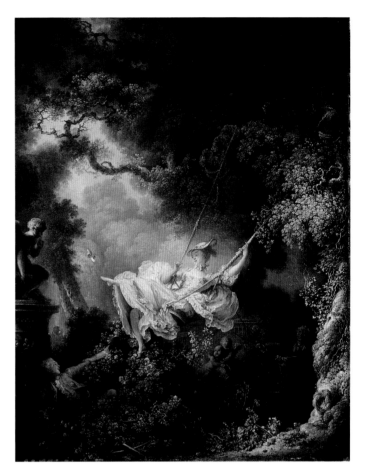

Lisa Yuskavage is known for her naughty/ innocent girl pinup paintings. *Faucet*, 1995, communicates to viewers through vulnerability, seduction, the interchange of seer and seen (or the dominant male gaze upon female sitters), color (of which Yuskavage is a master), light, shadow, drama, and most overtly, sexuality. The painting depicts a sitter from the artist's imagination—it is one of her last paintings before she began to use *Penthouse* for source material. Like Golden's male landscapes and Semmel's *Sex Paintings*, Yuskavage's works are loaded in terms of sexuality, psychology, and gender and power dynamics of the gaze. Using imagery that borders on porn, her images question the traditional artist/model roles. Further, and again like Golden, she interrogates what it means to be a woman making images that exploit visual tropes associated with how men see women. If a woman makes porn images, is she parodying male objectification of women, or the male gaze? Is she acknowledging or denying its validity?

Indeed Yuskavage has often described the bodies and grounds in her works as "landscapes," thinking in particular of sunsets. *Faucet* possesses this atmosphere, as the figure is set against a yellowish-pink color field that matches the girl's peachy bare breasts and soft blond hair. This cohesiveness makes the painting verge on being monochromatic. Here pastiche operates on several levels, from color to scene, with an overall palette that is reminiscent of the girl's dress in Jean-Honoré Fragonard's *The Swing*, 1767. Like the subject in that work, Yuskavage's girl wears a delicate pale cardigan with an ornate collar, in a way referencing the frilly, chaste, and idyllic genre of French Rococo. Her painting gleans a similar romantic drama, yet its elegance is interrupted with soft porn.

Saville and Yuskavage both internalized a history of light, color, and form on a two-dimensional surface but with very different outcomes. Yuskavage's women reside in a hyper-sexual, fairytale, naughty-girl zone, whereas Saville's large-scale works reside in the flesh—in its bulk and folds. Although both painters sidestep conversations about feminism and body politics in interviews, they undeniably create works with a female perspective and a sense of spectacle.

Rita Ackermann
Get a Job, **1993**
Acrylic on canvas
48 × 60 inches
Jennifer and Jon Weaver
© Rita Ackermann, Courtesy the Artist and Hauser & Wirth
Photo: Orcutt & Van Der Putten

In contrast to Yuskavage's and Saville's rich color, Rita Ackermann works in a limited palette. Her early works, such as *Get a Job*, 1993, feature fairytale-like young teen girls who smoke, lounge, talk on the phone, fantasize, experiment with sex, appear bored and apathetic, and waste time. Ackermann has described these paintings as metaphors for freedom, including the boundaryless, and therefore daunting at times, position of being an artist. As the artist is a Hungarian immigrant who has lived in New York since the 1990s, the works have also been discussed as politically symbolic, expressing the freedom of democracy and capitalism but also their potential for failure. Ackermann's formal concerns include blurring the lines between representation and abstraction; creating a gestural, rhythmic flow; using pared-down color—in this case, black, white, and red; and mark-making that is between drawing and painting and is suggestive of the immediacy and ephemeral nature of a chalkboard. Ackermann conveys femininity through her look-alike nymphettes (who also look like versions of her) to express the complexities of social order and gender archetypes that can be conformed with or rebelled against, beginning in the tender teenage years. The girls in *Get a Job* are indifferent to our view of them.

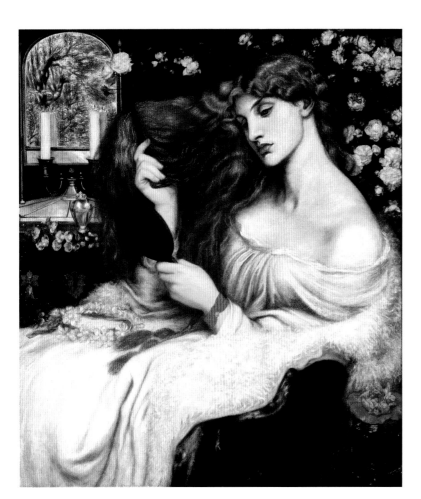

The ongoing series of Pre-Raphaelite–inspired bathers by Marilyn Minter shows women with their bodies seductively pressed against what appears to be a steamy shower glass. The condensation obscures a crisp view of the subjects, blurring Mulvey's theory of the "to-be-looked-at-ness" of female bodies as prescribed by male creators and viewers. At the same time, these paintings appear solidly within the framework of seduction. Minter also works within feminism, body politics, and overturning the male gaze: "I'm interested in operating as a female voyeur. They (her subjects) don't return the gaze because they go about their lives. They are not posing for Instagram or implying that they are being watched." Even so, "There is a level of objectification anytime a figure is depicted. Whenever clothing disappears from the human body, it becomes seductive."[14]

Minter makes visible her bathers' tattoos and pubic hair as elements of realism. *Red Flare*, 2018–19, shows a conventionally beautiful redhead, arms raised, seen in profile as she washes her hair; under her right arm, we see the shadow of armpit hair. The artist has said that she challenges herself to make images of what we know exists but that we never see:

> *Throughout art history, with the exception of a handful of women artists, images of women grooming are painted by men. I wanted to see what a twenty-first-century bather would look like. … Pit hair and pubic hair are preoccupations of mine. They have been erased from art history (maybe artists deemed body hair too vulgar to paint). I thought I would make a case for body hair. Showing it as beautiful, natural, and attractive.[15]*

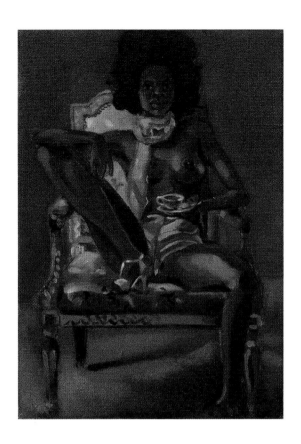

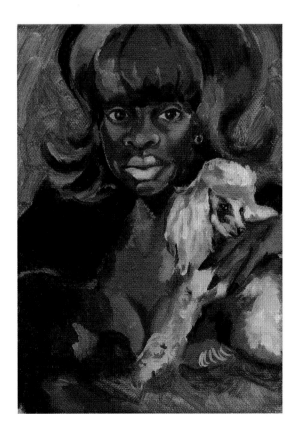

Somaya Critchlow

Clockwise from top left:
***Figure Holding a Little Teacup*, 2019**
Oil on linen
8 ⅜ × 5 ⅞ inches
Laura & Barry Townsley, London

***The Wait of Silence II (Afternoon Tea)*, 2020**
Oil on linen
20 × 14 inches
Green Family Art Foundation, courtesy of Adam Green Art Advisory

***Kim's Blue Hair with Dog*, 2019**
Oil on canvas
9 × 6 ⅝ inches
Alvaro Jimenez Collection, London

Right:
***Untitled (Pink Hair)*, 2019**
Oil on linen
10 × 8 ¼ inches
Isabella Wolfson Townsley, London

© Somaya Critchlow

Unlike Minter, Somaya Critchlow often has her subjects meet and return our gaze, usually with a direct and provocative stare. She presents us with Black women, coquettish and confident, who enjoy a lineage within the canon of art history and contemporary pop culture at once—both areas that have been historically reserved for the subject of the white woman. There is a distillation of eras and artistic genres in her tiny boudoir portraits, which draw upon the voluptuous women of Rubens, the darkness of Diego Velázquez, present-day fashion, and pop culture. The women, placed in intimate domestic scenes, also recall Dutch still lifes as much as they do Rococo compositions or Paris Hilton's tacky socialite magazine pictures from the early 2000s. The mingling of history and present-day references suggests the systemic and longstanding problematics, progress, and lack thereof with race, class and gender. The artist's thinned-oil-on-linen works convey a moody sexiness at the same time they evoke kitsch. *Untitled (Pink Hair)*, 2019, for example, shows a close-up of a woman wearing a voluminous pink wig. The wig echoes the form of buttocks, and the woman puckers her lips, as if blowing kisses to the viewer à la Marilyn Monroe. Though her eyes are mostly obscured by the wig, her gaze is felt.

Critchlow's women, like Minter's, operate through seduction and intimacy (by way of scale and scene, with Critchlow), and both show single women in domestic spaces. Lisa Brice's female figures are also often situated in a domestic scene. Like Critchlow's, they are based in fantasy; like Minter's, Brice's women do not meet our gaze.

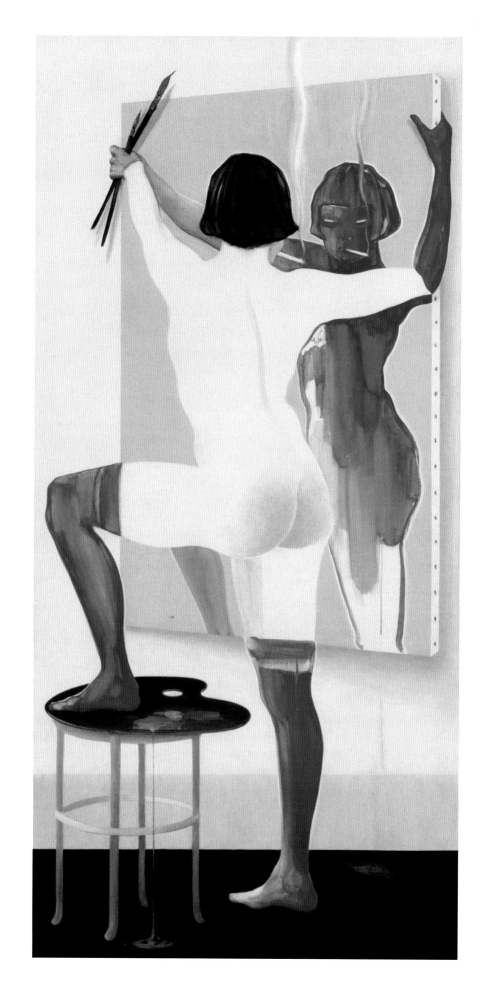

Lisa Brice
Untitled, 2020
Synthetic tempera and gouache on canvas
79 ½ × 38 ¼ inches
Green Family Art Foundation,
courtesy of Adam Green Art Advisory
© Lisa Brice

Brice's women are characteristically painted in cobalt or vermillion and white, partially to omit the personal details of her sitters. Drawing on the works of Degas, Manet, and Picasso, Brice subverts these prototypes, drawing attention to the way the familiar male gaze falls upon women but skewing the sitters' typical passivity. Instead, the women are self-involved and self-possessed. Usually pictured smoking, painting, lounging, or posing in lingerie, striped clothing, or nude, they do not seem to care who is looking at them, and they do not return a look. The subjects' indifference is similar to that of Minter's women, who do not return our gaze because they are going about their lives.

Reflections and doorways are two of Brice's most important framing devices to signify liminal spaces between interior and exterior and private and public. In *Untitled*, 2020, the woman has paint brushes in one hand and strikes a sexy pose, propping up one stockinged leg on a table with a painter's palette as a top. The woman looks away from us to study the canvas she holds up: a self-portrait, echoing her own pose. The artist/model dynamic here is ambiguous. Is this really a self-portrait? Is it an allegory for painting? Is it about subverting the male gaze? Brice has described her scenes as "cinematic outtakes," showing moments when the figures are in between shots, on their own time.[16]

The indifference toward the viewer of Brice's subject is overturned in Natalie Frank's work *Couple I*, 2021, which shows a woman engaged in sex but looking out at us. In this and much of her work, Frank investigates themes of power, sexuality, feminism, and identity through abstract passages of color that erupt into form. In 2011, Frank began an ongoing series of works based on the uncensored, original, raunchy, and violent stories of the Brothers Grimm (1812–57), which came out of the oral tradition of tales told by women to express their desires and fantasies to each other. Frank came across the unadulterated versions through her mentor and fellow artist Paula Rego, also in this exhibition, who has made a career of examining fairytales. Frank was attracted to the combination of feminine evil and divine power that came across in the stories and took up the idea of portraying visual versions.[17]

As in the Grimm works, there is a salacious and wicked, fairytale-like quality to *Couple I*, a kind of collage combining fantastical landscape wallpaper depicting a field of giant poppies with a gouache-and-pastel image of two lovers (a woman lying down and a man to her right) engaged in oral sex. In this moment of passion, the woman (recipient) looks out at the viewer. This outward gaze is characteristic of Frank's work. "Despite being in a sexual situation," the artist explains, "her mind is elsewhere, perhaps with the viewer, or a third party in the room watching them. It is unclear."[18] Frank often paints women in narrative scenes such as this, both inside the action but also partially

Natalie Frank
Couple I, **2021**
Mixed media
168 × 288 inches
Natalie Frank
© Natalie Frank
Photo: Farzad Owrang

withdrawn from it. The women, then, "can become both actors and spectators . . . and there is a power in not losing yourself in whatever narrative you believe yourself to be in. This awareness points to the easily disrupted illusion that reality is." That her figures emerge from and dissolve into abstraction reinforces this idea. The oversized poppies are a way to simulate the "sexual explosion that is occurring in the picture. The poppies (nature) are uncontrolled and something that the reclining woman might aspire to. Her moment is smaller, human, and framed as limited, especially amidst the expanding landscape."[19]

Sylvia Sleigh
The Turkish Bath, 1973

Oil on canvas
76 × 102 inches
The David and Alfred Smart Museum of Art,
The University of Chicago; Purchase,
Paul and Miriam Kirkley Fund for Acquisitions
Photography © 2021 Courtesy of The David and Alfred Smart
Museum of Art, The University of Chicago

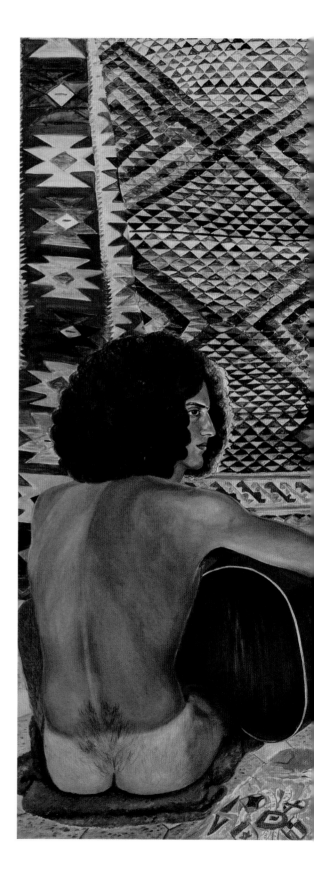

Sylvia Sleigh and Mickalene Thomas turn the tables on the classic theme of the reclining woman, seen in such works as Jean-Auguste-Dominique Ingres's *The Grande Odalisque,* 1814, depicting a female Turkish bather (often understood as a concubine or prostitute). Sleigh and Thomas look at subjects through class, as with the early examples, and through the contemporary lenses of gender and race. In *The Turkish Bath*, 1973, Sleigh subverts the traditional odalisque by closely citing Ingres's *The Turkish Bath*, 1862, but replacing women with male nudes. The men, while seductive in some ways, stand out because their anatomical angularities and hairy bodies don't display the soft curves of the female forms we expect to see. Sleigh's husband, the art critic Lawrence Alloway, is the central reclining nude in the work, adding another satirical note to this feminist statement by suggesting that he is her prostitute or concubine. This role reversal calls into question the values historically used to paint women and men, while it also points to the lack of erotic male nudes in works of art throughout time—a subject taken up directly by other artists of Sleigh's generation included in this survey, such as Golden and Semmel. Like Sleigh, they rejected censorship of male nudity and sought to present erotic imagery for (straight) women. As it turns out, their inclusion of penises was discussed more within the language of politics than that of eroticism.

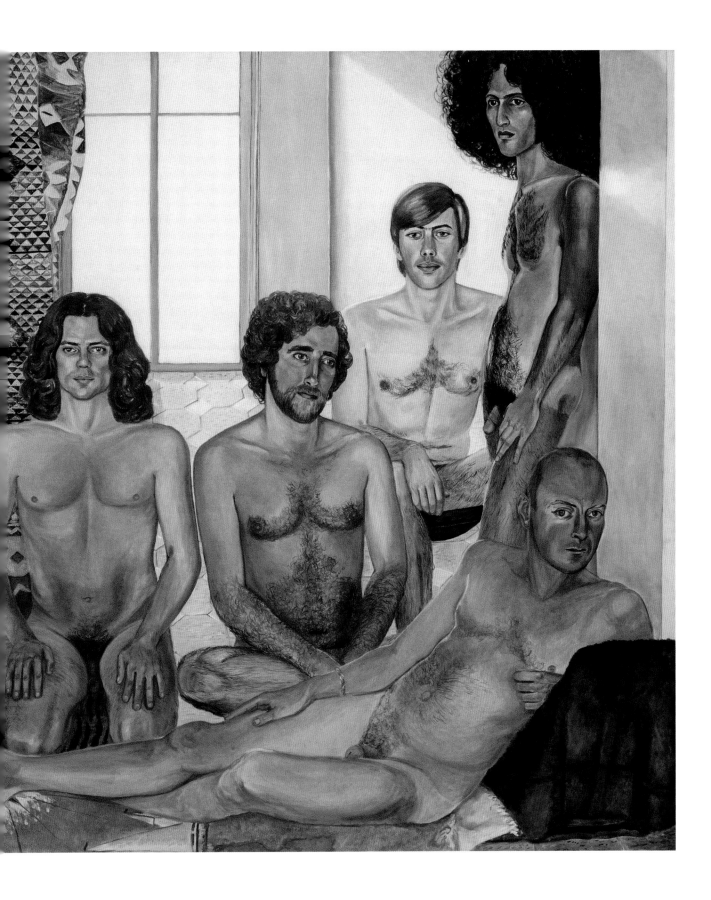

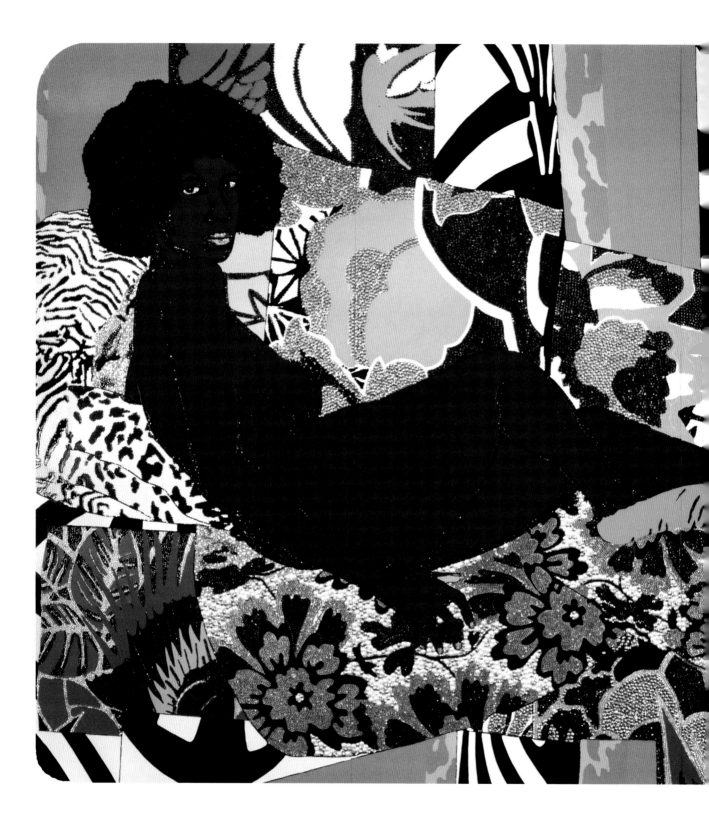

Mickalene Thomas
A Little Taste Outside of Love, **2007**

Acrylic, enamel, and rhinestones on wood panel
108 × 144 inches
Brooklyn Museum, Gift of Giulia Borghese and Designated Purchase Fund, 2008.7a-c
© 2022 Mickalene Thomas / Artists Rights Society (ARS), New York

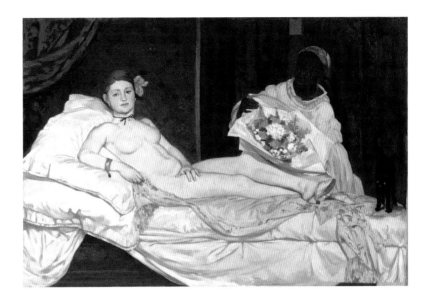

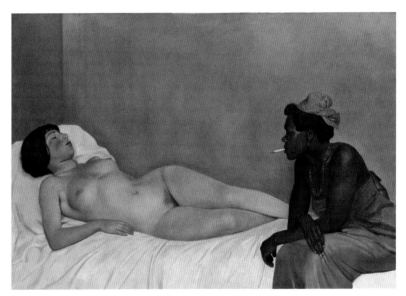

Édouard Manet
Olympia, 1863
Oil on canvas
51 ⅜ × 74 ⅞ inches
Musee d'Orsay, Paris
© RMN-Grand Palais / Art Resource, NY

Felix Vallotton
The Black and the White, 1913
Oil on canvas
44 ⅞ × 57 ⅞ inches
Hahnloser-Jaeggli Stiftung, Winterthur
© Hahnloser-Jaeggli Stiftung, Winterthur / HIP / Art Resource, NY

Mickalene Thomas's monumental painting *A Little Taste Outside of Love*, 2007, has a similar lineage as Sleigh's *The Turkish Bath*: both recast the traditional (male-painted) odalisque to make a critical statement about the representation, objectification, and sexualization of women. However, Thomas focuses on Black women. In her work, Thomas quotes Manet's *Olympia*, 1863, which depicts a contemporary nude white female, identifiable as a prostitute, accompanied by a Black female servant. Thomas's version places the Black woman alone in the spotlight and makes the nude odalisque a 1970s pop culture icon. The image directly confronts patriarchy's dominant narrative and its problematics regarding race and the omission of Black women, both as subjects and creators. Although it is well documented that Thomas cites Manet in her painting, art history is filled with depictions of odalisques and with issues of race and gender. For example, in Felix Vallotton's *The Black and the White*, 1913, the Swiss/French artist depicts the typical passive white female nude, napping on a bed, with a Black woman gazing at her from close range, as she sits on the same bed. The symbolism—one woman napping nude, with the notable contrast to her pale body being her flushed cheeks; and the other woman awake, with a casual posture, watching her while smoking a cigarette—suggests a post-coital scene. Here, the Black woman is clearly in a power position that could be interpreted as a male role. While the dynamics between the sitters are unclear, the play on race, gender, and power structures is evident and bridges to the works of Sleigh and Thomas.

Further exploring inclusivity and gender fluidity are Celeste Dupuy-Spencer, Jenna Gribbon, and Apolonia Sokol, a group of figure painters at the fore of a turn toward queer romantic and personal imagery. Dupuy-Spencer is considered part of this movement, with works like *Sarah*, 2017, which depicts the artist in an intimate moment with her lover. After being in the Whitney Biennial in 2017, Dupuy-Spencer explained that she needed a reboot: "I made a decision to paint things and people I particularly loved. It's a way of super-personalizing a painting and putting myself deeply inside the situation. … *Sarah*, the painting I made of me and my partner, has a personal note painted for her on the back. I wanted to make it really clear that I wasn't making that painting to talk about gender or sexuality, or to shock anyone or tell anyone anything, but as a love letter."[20] Tenderness and domesticity come through in the image. The two women are semi-nude, Sarah in men's briefs, as the artist gently caresses her neck and head and their cat steps in to nuzzle Sarah's hand. The patterns of the rugs, the art on the walls, and the natural light dappling their skin create a peaceful ambience. Yet the quiet, contemporary scene also possesses elements of the Baroque, seen in the exaggerated poses of the figures and in their dramatic foreshortening and frontal positions. The theatricality and romance of the scene balance its focus on sexuality and self-reflection in ways that also recall the Austrian Expressionist Egon Schiele, known for gaunt self-portraits that emphasize male musculature, exaggerated Adam's apples, and angularities to express male sexuality.

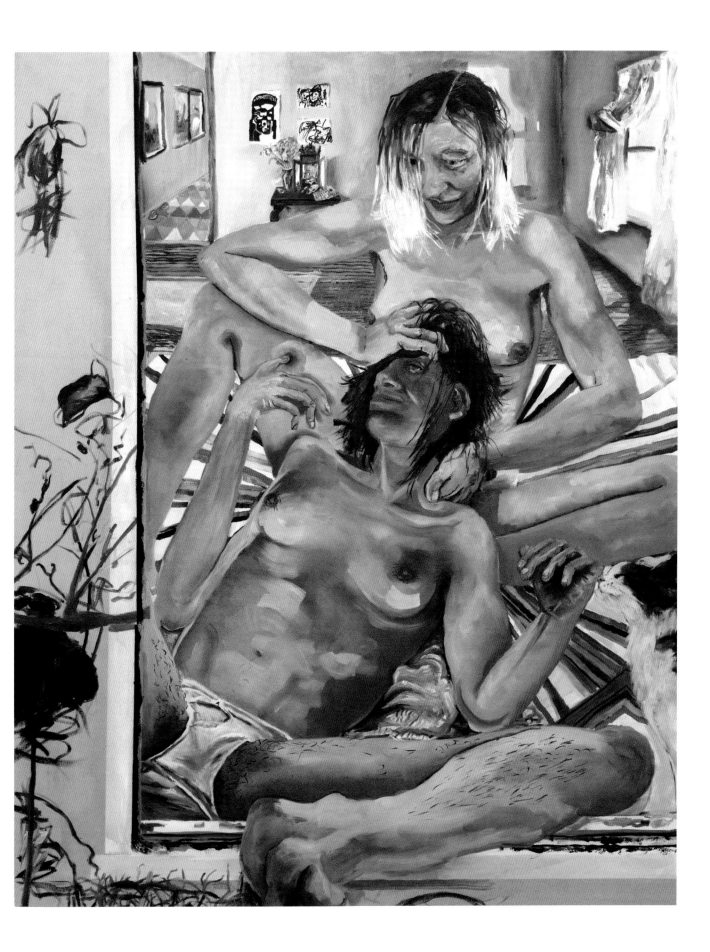

Jenna Gribbon
Weenie Roast Wrestlers, 2019
Oil on linen
60 × 42 inches
Private Collection, Germany
© 2022 Jenna Gribbon / Artists Rights Society (ARS), New York
Image courtesy the Artist and Fredericks & Freiser Gallery
Photo: Cary Whittier

A Baroque chiaroscuro infuses *Weenie Roast Wrestlers*, 2019, part of Jenna Gribbon's series depicting female wrestlers. The paintings address queerness through awkward and staged scenes that take place in settings drawn from the artist's childhood memories of growing up in Tennessee. In *Weenie Roast*, two semi-nude women at a campground attempt to take each other down to the ground. The scene brings humor to the fore—hot dogs symbolizing the male phallus are shown scattered and squandered. The over-the-top artificiality and quirkiness of the series is reinforced by the women's fluorescent pink nipples. The artist explains, "I'm participating in the current debate over whether women's nipples should be censored on social media or covered in public. The color is meant to create a slight discomfort: the nipple is the place where you're not supposed to focus, but here you can't help it. The idea is to make viewers self-conscious of the way that they're consuming images of bodies. The neon nipples invite you in, but they make you think about where you're looking and why, while also being a bit playful and silly."[21]

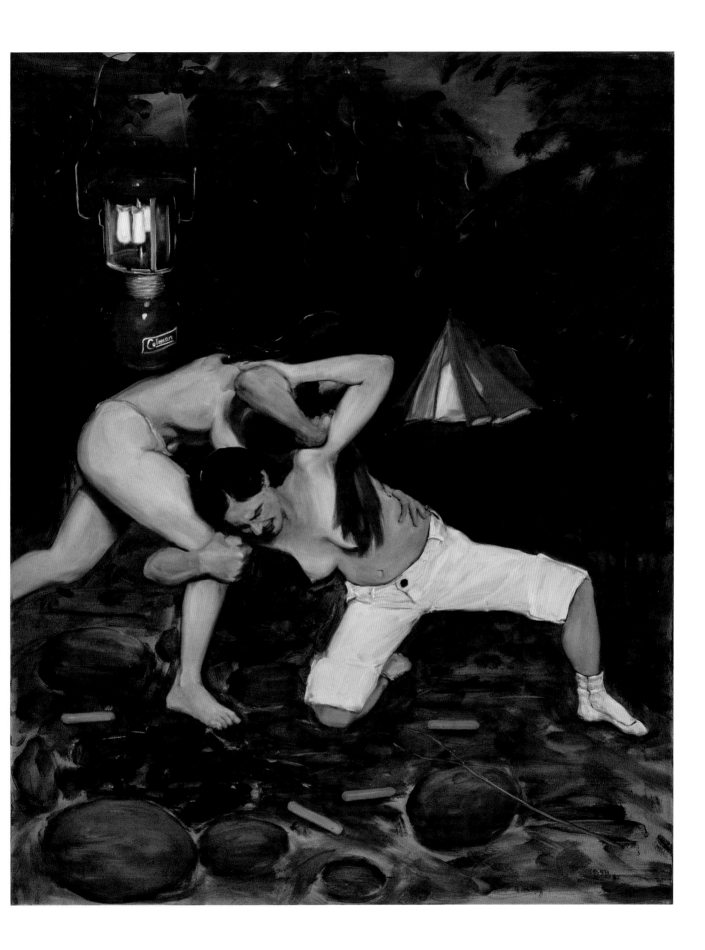

Apolonia Sokol
*Le Printemps (Spring) Linda, Nicolas,
Raya, Dustin, Simone, Nirina, Claude,
Bella, Dourane*, **2020**

Oil on linen
78 ¾ × 149 ⅝ inches
Courtesy of the Artist and THE PILL®
Work produced by MO.CO. Montpellier Contemporain
© Apolonia Sokol, Courtesy of the Artist and THE PILL®
Photo: Marc Domage

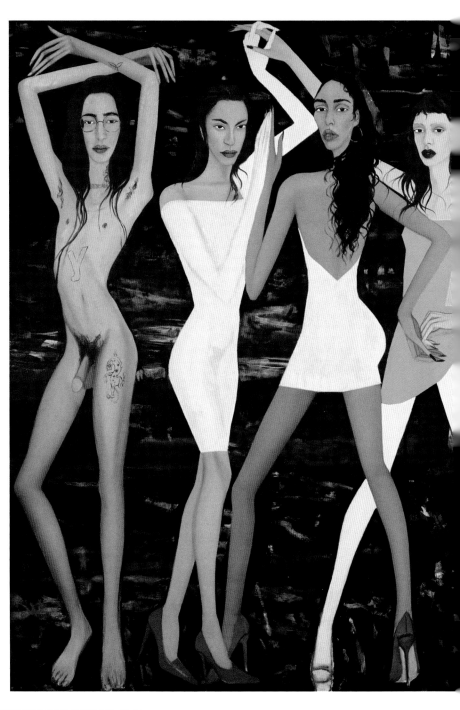

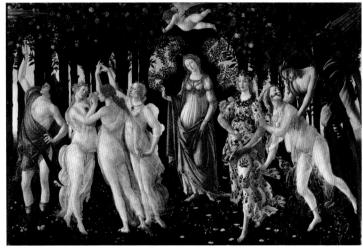

Sandro Botticelli
Primavera, c. 1481

Tempera on wood
79 ⅞ × 123 ⅝ inches
Uffizi, Florence
Scala / Art Resource, NY

Apolonia Sokol is known for her political portraits that speak to marginalization, femininity, queerness, and body politics in general. Taking its title and elements of its composition from Botticelli's large panel painting *Primavera*, c. 1481—an allegory for spring and the fertility of the earth—*Le Printemps (Spring) Linda, Nicolas, Raya, Dustin, Simone, Nirina, Claude, Bella, Dourane*, 2020, depicts nine figures, all trans women or gender fluid. While Botticelli's frieze illustrates the codes of femininity that operated in his time, Sokol's painting does the same in terms of today. *Le Printemps* emancipates the subjects and represents them without fetishizing or reinforcing transphobia.

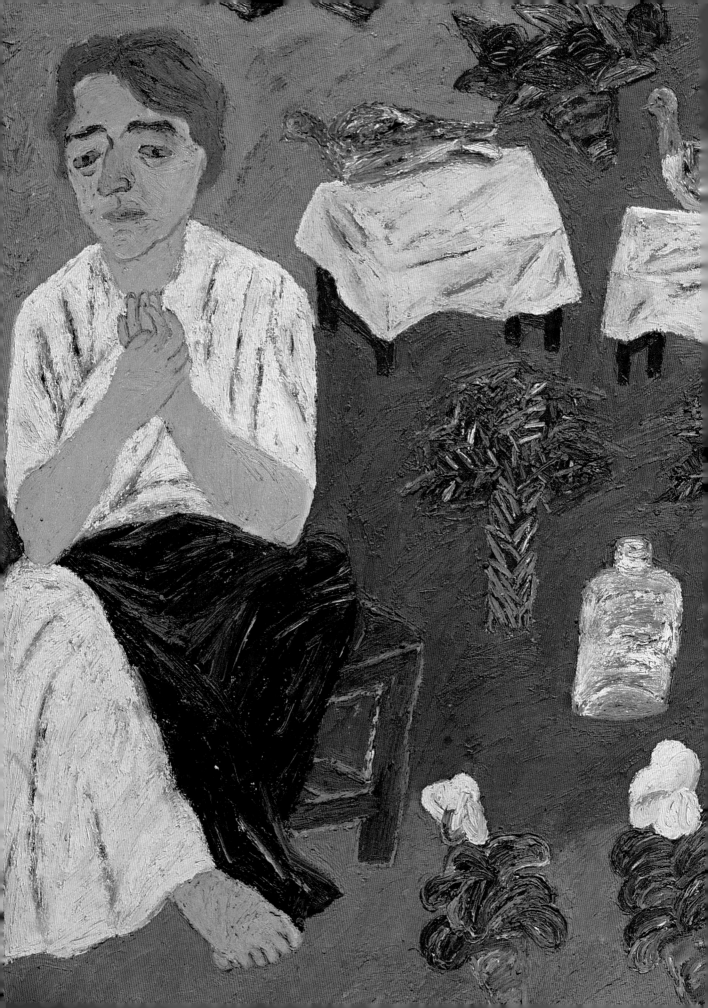

Color as Portrait accounts for the exaggerated or dramatic use of color, within or alongside form, to convey content about identity, including race, gender, and archetypes.

As mentioned earlier, what Laura Mulvey did not acknowledge in her text on the male gaze was that there is an implicitly white gaze (by the viewer, regardless of gender) upon white women (the sitters). Like bell hooks did in her text, several artists in *Women Painting Women* address this topic in subtle and overt ways. Emma Amos, like Faith Ringgold and, later, Amy Sherald, employs specific treatment of skin tones to obscure a pinpointing of skin color as part of her exploration of identity. Amos's *Three Figures*, 1966, is discussed here for this reason, but another painting of hers, *Woman with Flower Pot*, 1968, is reviewed through the theme of Selfhood. While both images could be discussed in either section, this again exemplifies the openness of the different threads. Amos, Ringgold, and Sherald, in their works discussed in this section, insert ambiguity about actual skin color, yet that they are painting women of color is completely unambiguous.

The other artists in Color as Portrait deliver a variety of outcomes through their use of color. Blue dominates Hope Gangloff's presentation of a white woman in a serene scene, while Lorna Simpson's blue denotes a craggy frigid landscape with a female figure that connects to issues of race. Likewise, Alex Heilbron inserts the image of a young woman in her work, but this time through geometry and color instead of landscape. Using large swaths of red and yellow, Joan Brown and Ania Hobson create sensations of isolation. Arpita Singh uses brilliant color and loose patterns in frenetic scenes centered on women, while Nicola Tyson and Louise Bonnet employ cartoon form and vibrant color ironically to provoke an existential and somber mood.

When Amos and Ringgold matured as Black women artists in the 1960s, they actively navigated the waters between the women's and civil rights movements in America and their own hard-won positions in the art world. Each explores color, of skin and scene, to underscore and shake up exclusivity. Amos painted the subjects at hand in life with flattened patterns, bold colors, and a pop sensibility beginning in her early development as an artist. Race was brought to the fore in works such as *Three Figures*, which depicts three women, seated and semi-nude. The women are portrayed not only with various shades of skin tone but also with multiple colors of skin within each figure, a hallmark of Amos's work from this period. The painting reflects the idea of women of many colors, and the addition of greens, reds, blues, and whites reinforces this notion. Color here suggests exoticism and otherness within a scene comingling Black and white American middle-class life—a subject rarely broached by a woman artist in the mid-twentieth century.

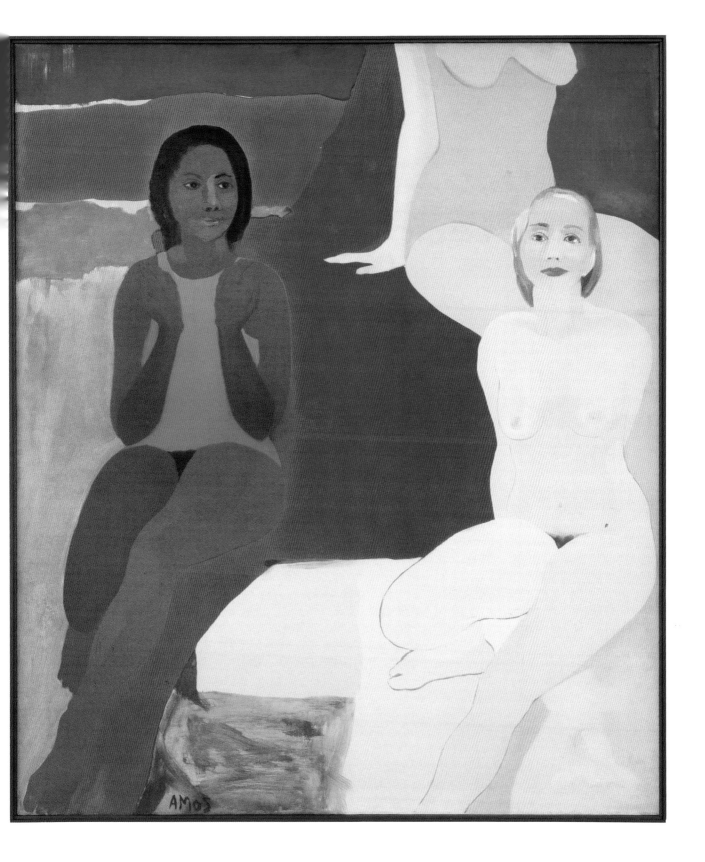

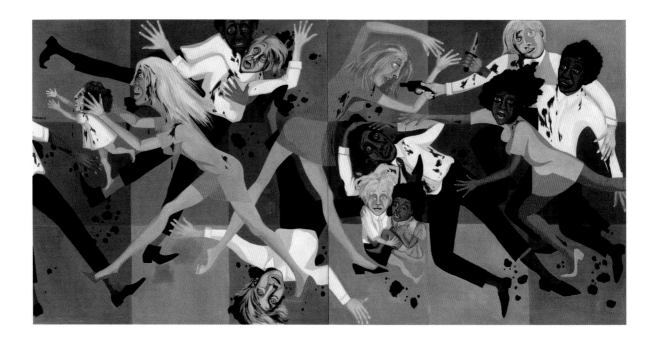

When *Three Figures* was painted, Amos was a part of an African American artist collective in New York known as Spiral. Growing uncomfortable with the idea that the group was defining (confining) what Black American life should look like, Amos left the group but continued to make portraits of women that addressed her conceptual concerns. Her images became increasingly political and challenging to the representation of race and gender in the canon of art history.

Many women artists of color coming of age, like Amos and Ringgold, at the intersection of the women's movement and the civil rights movement felt divided because the women's liberation movement was largely white and middle-class. A native of Harlem, Ringgold started her career as a landscape painter in the 1960s. As feminism and the civil rights movement began to take shape, Ringgold began to find her voice, shifting gears from landscapes to painting the figure in what would become a series of reflections on the interracial tensions of the day. *Early Works #24 Woman in a Red Dress*, 1965, is part of this shift, which is stylistically marked by post-cubist forms combined with influences from African sculpture. In 1963, the year of the March on Washington, Ringgold began a series of twenty paintings titled *American People*, in which she depicted singular people and groups, including white and Black women and men of diverse economic backgrounds. The works, when hung tightly together, signify the intersections of race and gender, exclusionary social practices, and social injustices that characterize much of American culture. The series culminated in *#20 Die*, 1967, which depicts the violence and bloodshed of the race riots of the time.

Woman in a Red Dress relates to the *American People* series. The rich palette of deep red, green, teal, and black dominates the image of the woman standing in a lush garden. Alone, as if escaping the party, the woman is rendered with heavily made-up eyes and wearing a red cocktail dress. Her skin tone is brownish red, in almost complete unity with her clothing. Her features are indistinct, and her hair is straight. Color and seclusion in these works divulge a psychological mood. Race and social division were at the fore for Ringgold at this time, especially as women artists had few opportunities in the art world in the 1960s, and Black women even fewer. By portraying her subject in *Woman in a Red Dress* as a bourgeois Black woman, the artist breaks with stereotypes to address issues of the myth of the American dream, race and gender inequalities, and layers of difficulty navigated by women of color across class divisions.

Faith Ringgold
American People Series
#20: Die, 1967

Oil on canvas; two panels
72 × 144 inches
The Museum of Modern Art, New
York; Purchase, and gift of The
Modern Women's Fund
© 2022 Faith Ringgold / Artists
Rights Society (ARS), New York,
Courtesy ACA Galleries, New York
Digital Image © The Museum of
Modern Art / Licensed by Scala /
Art Resource, NY

Faith Ringgold
Early Works #24 Woman in
a Red Dress, 1965

Oil on canvas
33 × 18 inches
Courtesy ACA Galleries, New York
© 2022 Faith Ringgold / Artists Rights
Society (ARS), New York,
Courtesy ACA Galleries, New York

Amy Sherald
A Midsummer Afternoon Dream, 2020
Oil on canvas
106 × 101 inches
Private Collection
© Amy Sherald, Courtesy the Artist and Hauser & Wirth
Photo: Joseph Hyde

Subsequent generations of Black women artists, including Amy Sherald, continue to grapple with issues of race and gender. The title of Sherald's *A Midsummer Afternoon Dream*, 2020, refers to William Shakespeare's comedy of mistaken identity and misplaced affection, *A Midsummer Night's Dream*. The play begins "Now, fair Hippolyta." Fair, as described by the performer Aldo Billingslea in an anti-racist webinar hosted by Shakespeare's Globe, means white and beautiful. Another line, in the play's second act, "Who will not change a raven for a dove?," is a further example of the racially charged binary language used to describe beauty/unattractiveness and good/evil.[22]

Sherald has placed herself within the tradition of portraiture as an American painter of the everyday and a Black figure painter who paints Black people.[23] Color, as Sherald employs it, often makes the portrait, but not when it comes to skin tone. She is known for gray, even skin tones that are often discussed as her way of neutralizing specific questions of ethnicity to instead emphasize familiarity. This approach is also a way to defuse the white gaze upon Black bodies. The gray stands out because it takes away from individuality, and it is a deliberate choice on the artist's part that works in unison with vibrant colors to tell us something of her sitter's identity. She explains that Blackness has been "codified to represent resistance."[24] Her works aim to undo this notion. In *A Midsummer Afternoon Dream*, the sitter's striking blue dress, tonally aligned with the sky but more prominent against a swath of dark green grass, brings our eye straight to her. Blue is symbolic of open spaces, as in the sea and sky, and this idea translates to freedom—here the freedom for a Black woman to experience leisure time. The title and scene work together to convey a sense of serenity and relaxation. The figure, who has halted before a field of sunflowers, rests against her bicycle while her dog rides in the basket. She has been picking flowers. Sherald explains:

> *I have been engaging with landscape imagery in my paintings as a way of having a more expansive conversation about everyday Black American experience. To me the incorporation of the background elements in this piece—a bicycle, the flowers, the white picket fence—is less a departure from my existing practice than a way of opening up narratives already present in the work. These aspects contribute to a story about leisure, about private moments of leisure, and to whom leisure belongs.[25]*

Depictions of leisure time are notably associated with eighteenth- and nineteenth-century France and scenes that were painted by white men, usually with white women as their subjects. Sherald takes possession of a tradition that has excluded Black women, both as makers and as subjects, but there is also a side of the work that is about simply depicting a harmonious and peaceful scene that comes from real life. "I have always been interested in creating work that gives voice to those extricated from the dominant historical narrative and artistic traditions. Most of all, my work aims to serve as a place for reprieve, quietude, and joy, imaging leisure not just by picturing it but facilitating it."[26]

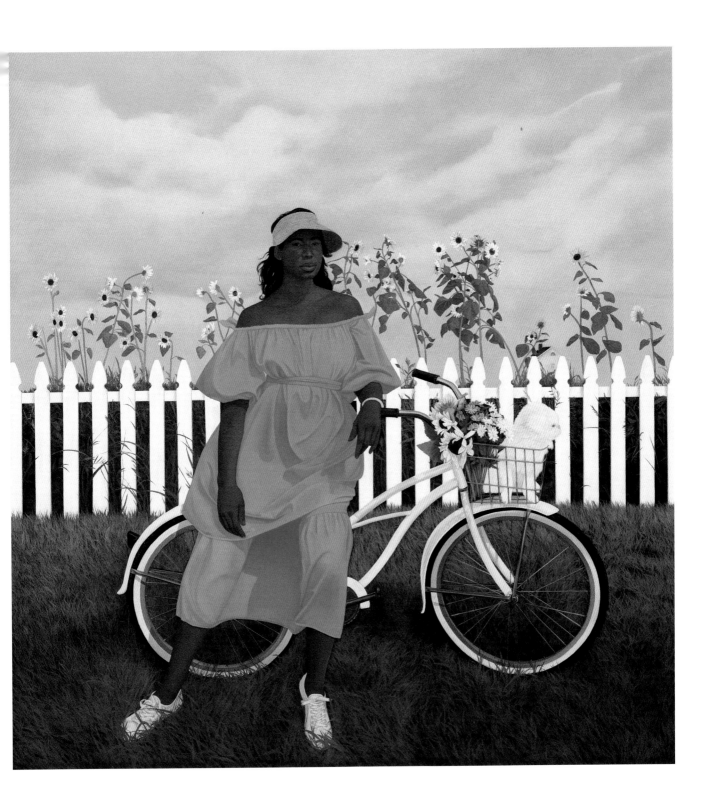

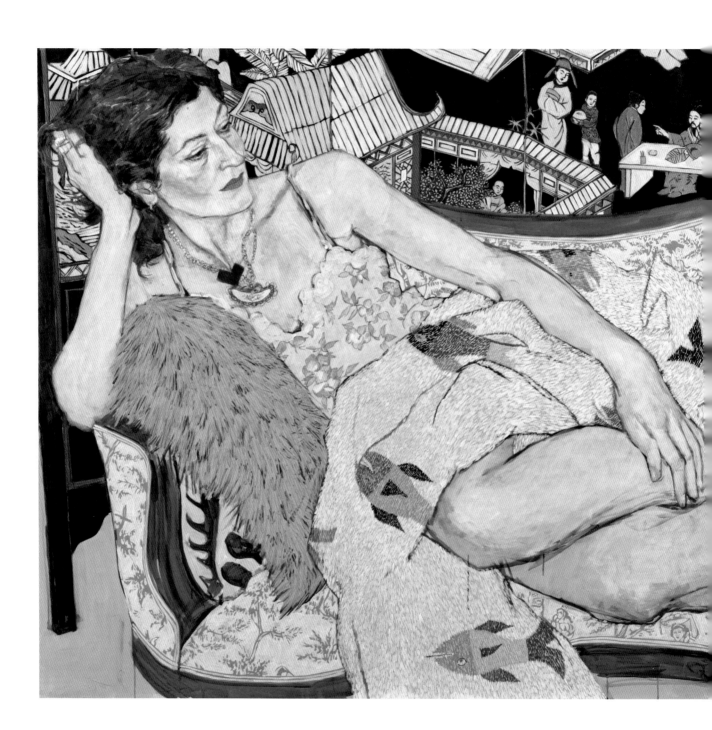

Hope Gangloff
Queen Jane Approximately, **2011**
Acrylic on canvas
66 × 108 inches
Collection of Alturas Foundation, San Antonio, Texas
© Hope Gangloff
Image courtesy of the Artist and Susan Inglett Gallery, NYC

Blue also plays a central role in setting tone and conveying content in the cozy domestic interior of Hope Gangloff's *Queen Jane Approximately*, 2011. She often paints her friends, most of whom are fellow artists, poets, and musicians. The work shares its title with the Bob Dylan song released in 1965, and the sitter is fashion designer Jane Mayle, whose Maison Mayle is located in Manhattan. As with much of Gangloff's work, the reclining subject takes up the majority of the large-scale canvas, as she lounges on a settee, with subtle references to the "exotic" odalisque appearing in the backdrop, upholstery, and dress. Similar in shades of blue, the work recalls Cézanne's *The Large Bathers*, 1900–06, and there is a kinship in treatment of the figures and composition. Yet Gangloff's portrait incorporates blue to suggest a calm and reflective mood, whereas Cézanne uses blue to convey expressiveness.

Lorna Simpson
Murmur, 2019

Ink and screenprint on gessoed fiberglass
Unique
108 × 96 inches
Collection of the Modern Art Museum of Fort Worth,
The Friends of Art Endowment Fund
© Lorna Simpson, Courtesy the Artist and Hauser & Wirth
Photo: James Wang

Since the mid-1980s, Lorna Simpson has addressed issues of identity, gender, race, history, and the politics of representation in her work, which is frank in questioning what it means to be a Black woman and an artist in a white male (art) world. Simpson has worked in varied media—photography, performance, film, and most recently painting—often pulling images from *Ebony* and *Jet* magazines as a backbone motif. In *Murmur*, 2019, the appropriated magazine image is embedded at left and is accompanied by disjointed words (text) in small vertical strips in the iceberg. The piece came after Simpson began to work on dark blue paintings related to the poem "Using Black to Paint Light: Walking Through a Matisse Exhibit Thinking about the Arctic and Matthew Henson," by Robin Coste-Lewis. In it, Coste-Lewis refers to the color blue to evoke an arctic scape in her description of the often-overlooked Black American explorer Matthew Henson, who was the first to reach the North Pole.[27] The woman is entrenched within icy blue glaciers; like the glaciers themselves, women occupy a precarious and vulnerable place on earth—shifts in climate and in the icebergs are a metaphor for the insurmountable challenges faced by Black women. The darkness, the oceans, and the icy atmosphere of the brooding landscapes in blue suggest a divide and an impossible encapsulation.

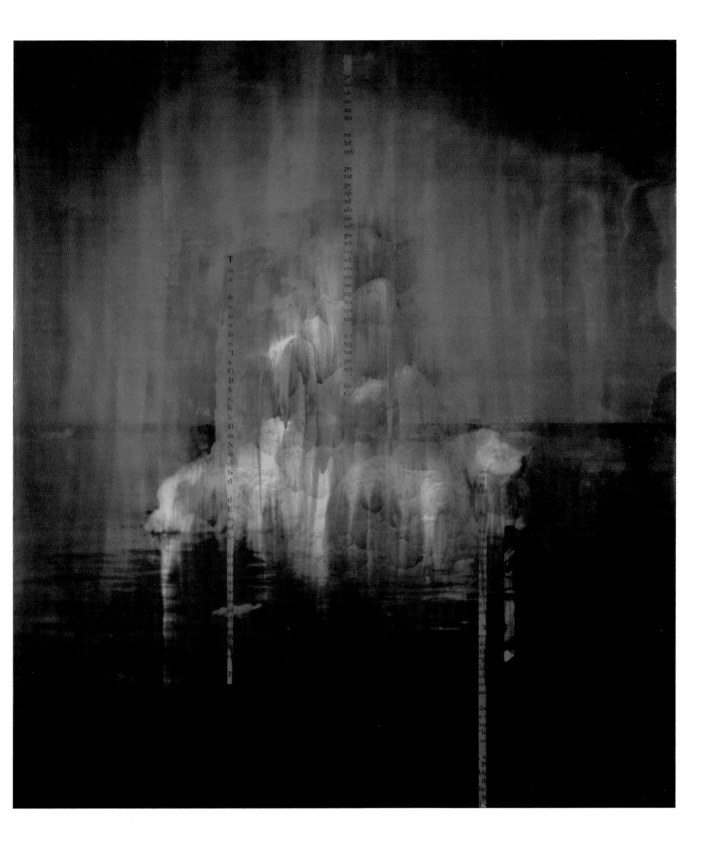

Like the main figure in Simpson's *Murmur*, the woman in Alex Heilbron's *Labor of Thought*, 2019, is buried, but this time in a matrix of pattern. The painter uses geometric designs in part to signal language and the way it is coded and conceptually understood. Color creates movement within the work, where the rhythm of the pattern moves from bottom right to top left. In the center is the fractured silhouette of a young woman with a ponytail. Although the ponytail is blurred here, the figure can be recognized from Heilbron's other works, where she frequently appears. Her silhouette amid the artist's otherwise abstracted construction switches up the logic of the work, from geometry to organic form and from abstraction to figuration. The seemingly opposing systems complement each other. The pattern becomes sentient through its association with the girl, and the girl becomes iconic and unreal when juxtaposed with the grid.

Alex Heilbron
Labor of Thought, **2019**
Acrylic on canvas
72 × 54 inches
Collection of Gloria and Howard Resin, Los Angeles
© The Artist, 2022
Image courtesy of Meliksetian | Briggs, Los Angeles

Joan Brown and Ania Hobson use primarily red and yellow to convey two differing moods. Contrasting the two colors, Brown created *Self-Portrait with Fish and Cat,* 1970 (not illustrated). Showing herself standing and extending the full height of the vertical canvas, Brown portrays herself with a paintbrush in her left hand and wearing studio clothes dappled with paint; she looks straight ahead. Brown was associated with the Bay Area Figurative movement and was known for her flat and stylized cartoonish figures often engaged in everyday activities. In this work, her love of animals is seen in the large fish she cradles with her right arm and in the cat at the lower canvas. The fish may represent Brown's passion for swimming.

Self-Portrait with Fish and Cat strikes a balance between the real and the fictitious. Brown's treatment of the self is unsmiling, stiff, and matter of fact. The fish is more animated than the artist—arching backward, its curved body moves the eye from upper to lower canvas, competing with the figure for attention. The bold red backdrop emphasizes the golden/yellow fish and the artist's blond hair. Color creates mood and expression, while the subject, the artist herself, remains deadpan.

Ania Hobson
Two Girls in a Bar, **2020**
Oil on canvas
49 ¼ × 57 inches
Green Family Art Foundation, courtesy of Adam Green Art Advisory
© Ania Hobson

The use of red and yellow along with a form
of caricature conveys a very different scene in
Two Girls in a Bar, 2020, by Ania Hobson. While
Brown stares straight ahead, expressionlessly,
toward the viewer, Hobson's women look to the
side, engaged in their own action, unconcerned
with our presence. Most of the canvas is divided
between red and mustard yellow, evoking
the nocturnal, cavernous atmosphere of a
bar. In *Two Girls*, the women's expressions say
everything. Looking off into the distance while
hunkered down over their drinks, they are half
bored and disinterested, but still they check out
the scene. They had perhaps hoped for more on
this night.

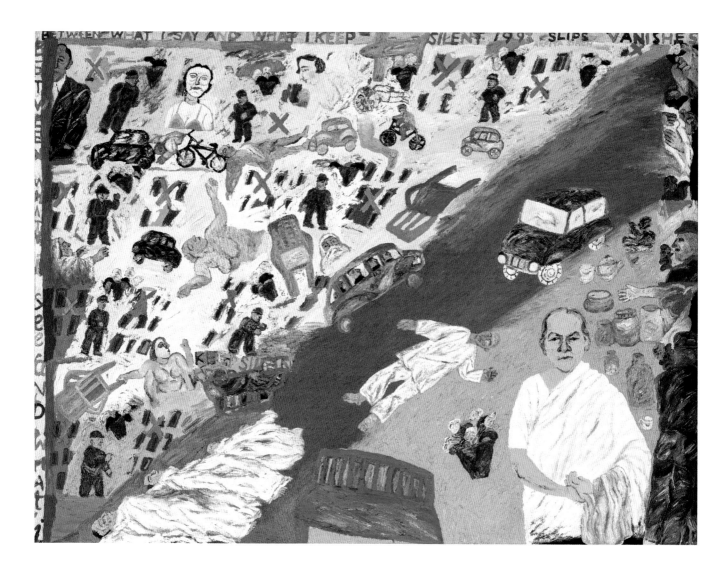

Foregoing any single dominant color, Arpita Singh's paintings unfold in narratives, usually centering on women. Within her energetic framework of pictorial folklore and contrasting hues, however, lies a sophisticated and subversive view of the roles of women in contemporary India. Her narratives are semi-autobiographical and often include references to the aging process, the onset of violence based on race and gender, and the emotional depths caused by loss and death. Taken as a whole, Singh's canvases depict an unfolding metanarrative, but section by section, each story becomes its own nucleus, with its own nuanced complexity.

Public and private lives comingle in Singh's canvases, where figures are situated against vivid backgrounds, as is the case with *Amina Kidwai with Her Dead Husband*, 1992, and *My Mother*, 1993. *My Mother* shows an urban scene with the words "between what I say and what I keep silent" painted along the top margin, among other phrases from newspapers. The composition is divided into three diagonal bands of brown, green, and white ground, each interspersed with pink, blue, yellow, red, and white. The busy energy of the city is palpable, and death is present—for example, in the mass grave at the lower left. The artist included the scene because around the time of this painting, a group was gunned down in northeast India.[28] Mixing the private with public and political events, as she does throughout her oeuvre, Singh depicts her mother at the lower right, looking back at us with clutched hands as she wears a white saree, which is a symbol of peace, spirituality, and purity.

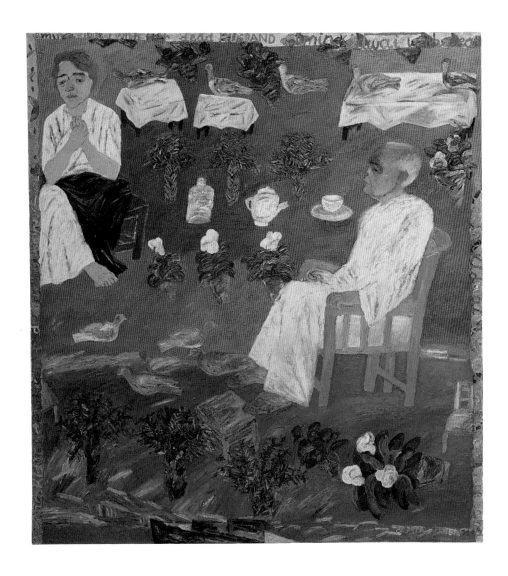

In *Amina*, the words "Amina Kidwai with her dead husband" are etched along the edges of the lively colored canvas that is divided into pink and blue, symbolic of nurturing and virtue. The colors also suggest the bright hues inextricably tied to Indian culture, and the notion of storybooks and storytelling through color, symbolism, and figuration. The couple is pictured in what is clearly a funerary scene. They float in opposite directions; the man is seated toward the lower right, with earth, plants, and flowers beneath him. The woman is praying from a higher plane, toward the upper left, as flowers, teapots, teacups, and a dove drift throughout the scene. The Kidwais were neighbors and close friends with Singh and her family. Singh has painted three generations of Kidwais in her works, saying, "I chose this family because I know all its members very well and can articulate whatever I want to express through them. In a way this family is a microcosm of contemporary India for me."[29]

Nicola Tyson
Donkey ride, 2021
Acrylic on linen
77 ⅛ × 77 ⅜ × 1 ½ inches
© Nicola Tyson, Courtesy Sadie Coles HQ, London and Nino Mier
Photo: Robert Glowacki

Donkey ride, 2021, by Nicola Tyson, combines intense color with cartoonish form to convey a psychological mood. The figure in pink, a version of a self-portrait the artist uses in much of her work, straddles a donkey. The colors and figures are eccentric, calling to mind James Ensor, Ernst Kirchner, or more recently, Maria Lassnig, also in this survey, who uses the body to comment on emotional states of being. The vivid image addresses feminism, especially in its subject matter of horse and rider, traditionally reserved for male sitters. Tyson lays claim to the subject, yet there is a comic absurdity to the work. That she depicts a donkey instead of a horse makes for a moment of humor, especially when paired with the cartoon forms and bold, flattened colors. Yet the humor serves as a portal to get through to a deeper existential message. The amorphous, melting, and flattened figure, her long brown hair flapping in the wind, is pictured alone in a field of colors that denotes land and sky at sunset. The solitariness is palpable, and given the date of the painting, 2021, relates to the idea of separation and quarantining.

Louise Bonnet, like Tyson, captures the alienation and social isolation felt globally during the past two years in *Red Interior with Seated Figure*, 2021. The work combines elements of surrealism with a Peter Saul-like cartoon style. A woman in a deep rust dress with an exaggerated body sits alone on a bench. Her tiny, faceless head is represented by a molded hood of blond hair that is a hallmark of Bonnet's work.

The protagonist in the work is inspired by Mona, a recurring character for Bonnet from the Agnes Varda film *Vagabond* (1985), about a French drifter. The story starts when Mona's body is found in a ditch and moves backward to piece together the events that led to her death. "The woman in the painting is a version of Mona," explains Bonnet. "Usually, the figures in the paintings are also a collective woman and hopefully even though they come from my own experience in the world, they still express some universal feelings."[30] Two sentinels hover at the protagonist's feet, perhaps taking her through the death process. The out-of-scale bodily features overtake the interior scene, and the band of red, suggesting the light of a dying sunset as it hits the room, aids in bringing our eyes directly to the figure who sits before it. Nocturnal loneliness seems to creep in. Interiority is conveyed not only in the setting but most importantly in the figure. The meatiness of her body, particularly her hands and feet, suggests the weight of her emotions, and her stretching physique is symbolic of psychological tension.

Bonnet's woman compares to Tyson's in the use of color and cartoon forms that border on the absurd. Both present figures that through bodily expression and setting create a private moment marked by introspection. Both artists' works cross over thematic terrains between Color as Portrait and Selfhood.

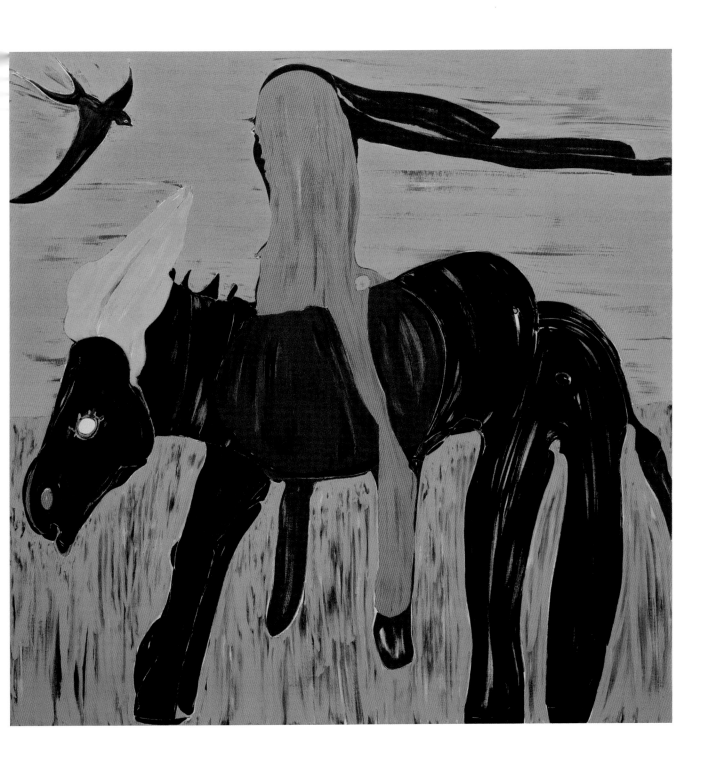

Louise Bonnet
Red Interior with Seated Figure, 2021
Oil on linen
84 ×144 inches
Steven Riskey and Barton Fassino
© Louise Bonnet

Selfhood is explored through representation of the self or a single identity, and through representations of the collective woman.

Nicole Eisenman
Close to the Edge, 2015
Oil on canvas
82 × 65 inches
Private Collection, Courtesy of Acquavella Galleries
© Nicole Eisenman, Courtesy the Artist and Hauser & Wirth

The theme of Selfhood examines the subtleties of gesture, posture, and setting used to portray the energy or presence of a sitter's psychological, as well as physical, state. Nicole Eisenman, Elizabeth Peyton, Danielle Mckinney, Njideka Akunyili Crosby, and Emma Amos present isolated figures in domestic settings to explore individuality and identity. Jordan Casteel portrays a lone woman, closely cropped from a scene on the subway. Paula Rego, May Stevens, Christiane Lyons, and Claire Tabouret probe archetypes, or the idea of the collective woman versus individualized women, and how such images relate to the real world. Deborah Roberts and Kim Dingle address childhood for girls; and Maria Lassnig, Marlene Dumas, and Dana Schutz offer simplified portraits with essential anatomical cues to imply psychological and physical states of being.

There is a distinct sense of loving attention to the formal qualities of painting in the works of Eisenman, Peyton, and Mckinney. Each of these artists presents glimpses of intimate and peaceful domesticity and individuality. Eisenman's work is often self-referential and usually combines cartoonish form with realism to varying degrees. Realism tips the scale in *Close to the Edge*, 2015. The painting shows a person napping with a cat as a breeze blows in through the open window. The scene is relaxed and serene—the needle of a record player has moved toward the center of the vinyl record; the music has stopped, and the person has drifted into sleep.

Eisenman's title is quite evocative. It specifically refers to the album on the record player, an epic compilation from 1972 by the English progressive rock band Yes. The painting and the album reinforce aspects of emotionality and creativity, with the idea of pushing boundaries. The title also perhaps refers to that moment between being awake and being asleep, or to the edginess of being anxious. It could be addressing conflicts of identity, including sexuality, race, gender, and class, but the scene—a seemingly spontaneous nap while listening to music—is a widely understood experience. "I paint the figure because I know the world through my body," the artist explained. "I understand my desire and my anxieties through my body, and the desires and anxieties of our culture."[31] The title and image are in opposition in *Close to the Edge*, creating an unresolved tension between serenity and nervousness.

Elizabeth Peyton
Klara, NYC, 2009-10
Oil on board
10 × 8 inches
Private Collection
© Elizabeth Peyton, Courtesy of the Artist and Gladstone Gallery

Elizabeth Peyton's expressive line and jewel-toned palette mingle the uniqueness of her sitters with stylization in her modestly scaled portraits of friends and cultural and historic figures. The tightly cropped view of her subjects heightens a sense of empathy, however. *Klara, NYC*, 2009–10, belongs to a series of meditations on friend and fellow artist Klara Liden. By studying one person, Peyton elaborates on individuality while addressing the fact that a different aspect of oneself can show up on any given day. In this view of Klara, the subject gazes back at us, her face passive, her posture rigid. Both Peyton's women and men often have features that range from androgynous to slightly feminized, and Klara leans to the androgynous side. Peyton also uses pared-down figures to express a mood. Despite generalized forms and blurred distinctions between female and male, a sitter's essence is revealed.

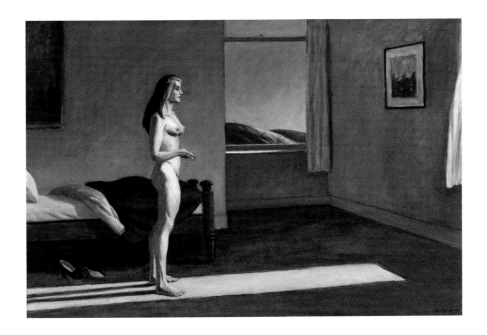

Like Peyton, Danielle Mckinney creates small-scale, moody portraits that can at first appear simplified but often capture a personal moment of solitary calmness through the intense use of color, as is the case with *First Glance*, 2021. In the otherwise darkened, nocturnal scene, a single lamp shines on a woman lying naked on a sofa as she gazes forward, seemingly in a pensive moment, with her cigarette burning in the ashtray that rests on the ground. At ease in solitude, the artist's figures—usually women in interior spaces, such as on a bed reading or in a chair drinking coffee—recall Edward Hopper's paintings. Like Hopper, Mckinney deploys light and shadow alongside vivid color to emphasize insularity and leisure. The paintings invite long looks, especially in that the sitter rarely gazes back at us.

Njideka Akunyili Crosby
Dwell: Me, We, **2017**

Acrylic, transfers, colored pencil, charcoal,
and collage on paper
96 × 124 inches
Collection of the Modern Art Museum of Fort Worth,
Gift of the Director's Council and Museum purchase,
The Benjamin J. Tillar Memorial Trust, 2019
© Njideka Akunyili Crosby
Photo: Kevin Todora

In the works of Eisenman, Peyton, and Mckinney, attention is on individuality and/or introspection. This is also true of Njideka Akunyili Crosby and Emma Amos, whose self-portraits, made nearly fifty years apart, show women in private moments in domestic scenes. Like Mckinney's *First Glance*, Amos's *Woman with Flowerpot*, 1968, and Akunyili Crosby's *Dwell: Me, We*, 2017, show interior scenes that suggest the security and peacefulness that being at home can bring.

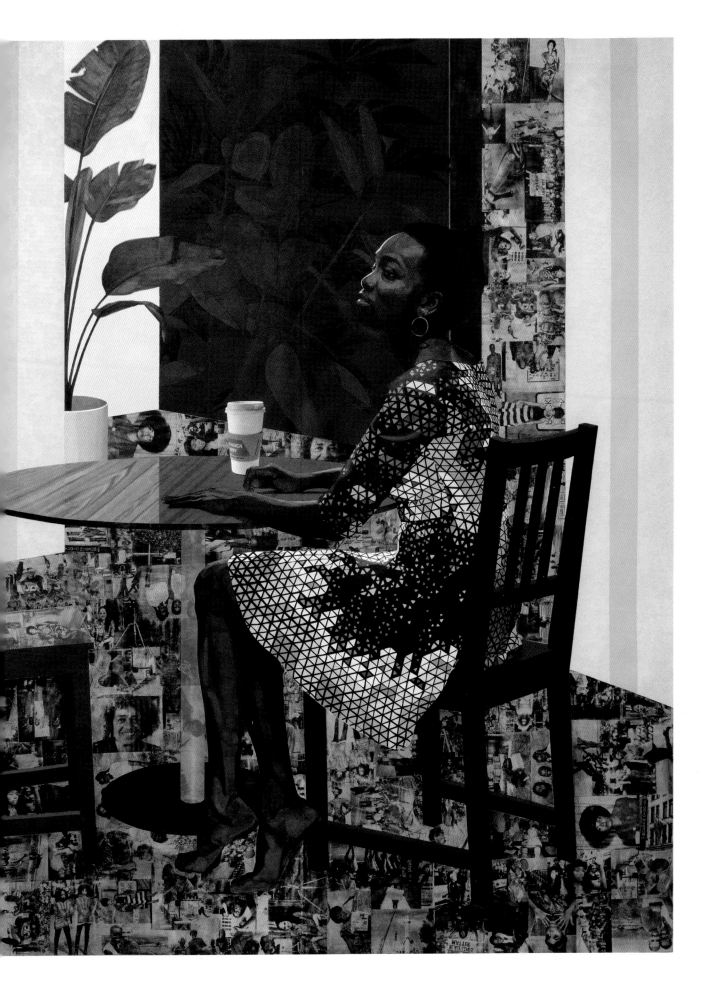

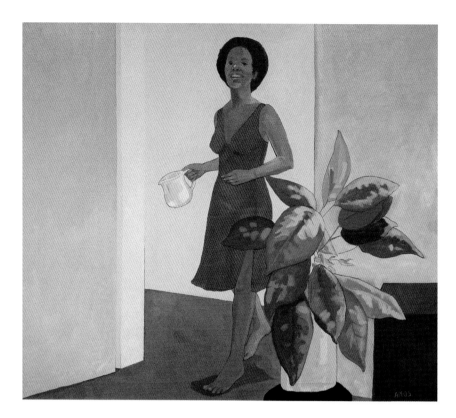

Emma Amos
Woman with Flower Pot, 1968
Oil on canvas
50 ½ x 44 ½ inches
Doree Friedman
© Emma Amos, Courtesy RYAN LEE
Gallery, New York

Jordan Casteel
Pretty in Pink, 2019
Oil on canvas
45 x 30 inches
Collection of the Artist
© Jordan Casteel, Courtesy the Artist
and Casey Kaplan, New York
Image courtesy Casey Kaplan, New York
Photo: Jason Wyche

Njideka Akunyili Crosby's *Dwell* also examines the dichotomies of the diasporic immigrant's notion of self, revolving especially around displacement and integration. The artist uses the layering of materials, including paint and collaged fabric and paper, to conjure a complex merging of cultures and layering of selfhood. Born in Nigeria, the artist moved to the United States at sixteen and is now married to an American man. The interplay between Nigerian and American imagery in the work suggests that identity is shaped by duality. In *Dwell*, there is a diversity of imagery, political and personal, that relates to her birth country and to the US. The painted bobble head portrait-within-a-portrait of Colin Kaepernick, the American civil rights activist and NFL quarterback, and the image of Angela Davis in the collaged "rug" beneath the artist's feet denote heroic figures on the one hand but also the endemic racism that comes with living in the US. Amos, Akunyili Crosby, and Mckinney each feature women of color (and each are self-referential) to show everyday aspects of domestic life, adding new dimensions to the largely white world of paintings of women at home.

Jordan Casteel's *Pretty in Pink*, 2019, moves into the public sphere but retains a sense of the private. It depicts a contemporary young Black woman on the New York City subway looking at her phone—beautiful and bedazzled, she is pictured with a pink outfit, eyeshadow, lipstick, embellished phone case, and backpack. Although she is on an urban mass transit system normally associated with crowds, her isolation and close view suggest a metaphor for the modern condition, in which we are all zoomed into our phones, and social interaction is increasingly limited due to the Internet, social media, and the pandemic. Casteel is known for painting the everyday from her community and has discussed the idea of representing the unseen. Through her focus on shared interactions and conversations, she embraces the nuances of lived experience. "With access comes responsibility," Casteel has said to describe her visibility as an artist and why it is important for her to treat each subject with reverence and care.[32]

Paula Rego
The Bullfighter's Godmother, 1990

Acrylic on paper on canvas
48 ⅛ × 59 ⅞ inches
Private Collection, Courtesy of Ivor Braka Ltd.
© Paula Rego, Courtesy the Artist and Victoria Miro

Paula Rego, May Stevens, Claire Tabouret, and Christiane Lyons depict variations on a collective woman as part of how we manifest the self, in a similar way to how we compare ourselves to unattainable archetypes, which are idealized amalgams of a specific type of woman, usually white, straight, and heterosexual. Rego destabilizes the male-centric Catholic culture she came out of, having grown up in Portugal during the António de Oliveira Salazar dictatorship. A feminist and activist, Stevens examines history and station in life to ruminate on women and their prescribed roles. Tabouret explores the general or collective notion of a young woman as a team player and looks at women historically to investigate how our individual identities are formed. Creating mashups of female figures, Lyons speaks to the objectification, the pressures of life, and the omissions of reality that archetypes can generate. Deborah Roberts and Kim Dingle do a similar thing with children, exploring the path to womanhood.

Rego has spent much of her career exploring issues related to feminism and folk themes linked to her upbringing in Portugal. She is known for her narrative paintings, pastels, and prints that derive from fairytales and have a storybook quality. *The Bullfighter's Godmother*, 1990, brings together the themes of folk culture and feminism in its depiction of a bullfighter being prepped and dressed by his godmother. The scene is set in a darkened, cloistral room where the godmother, standing taller than her godson, wears all black. A young girl wearing a white shirt and black tie sits in the room as well, with the red bullfighter's cape draped across her lap, which highlights the bullfight's origins in ancient fertility rites of sacrifice and connects it to the onset of fertility signaled by menstruation. The mood is somber, foreshadowing the matador's possible death. Godmothers in Catholic, authoritarian Portugal signify conformity in that they help their godchildren become devout and keep up tradition. Yet giving the woman the power in this image, both in her stature and in her action, subverts local traditions especially as relates to bullfighting, in which machismo equates with courage and reinforces patriotic and religious values.[33]

May Stevens
Forming the Fifth International, 1985
Acrylic on canvas
78 × 120 inches
© May Stevens, Courtesy of the Estate of the Artist
and RYAN LEE Gallery, New York

As a political activist and feminist, May Stevens was a founding member of *Heresies: A Feminist Publication on Art and Politics*, a journal published from 1977 to 1993, whose contributors included herself along with Amos, Golden, Ringgold, Hurtado, and many others. Along with Amos, she was also a founder of the Guerrilla Girls, a group of women in the art world formed in 1985 to fight sexism and racism; its founding members remained anonymous for many years, and its current members remain so.

Born a decade before Rego and in the US, Stevens was active as a painter from 1970 to 2010, creating works that mirrored her feminist values and crusade for social justice. *Forming the Fifth International*, 1985, is an iconic work within her oeuvre. It shows the artist's elderly mother, Alice, sitting in a field of green grass across from Rosa Luxemburg (1871–1919), the famed Polish-born socialist-communist and anti-war activist who was murdered in Berlin for her political outcries. Luxemburg is rendered in grisaille, a technique used by Stevens to signify a historical time period, and Alice is in color. The title refers to the drive to form an international union of radical political parties. In the image, the two women from different generations and with varied lifestyles and relationships to feminism are in dialogue: one, a Polish revolutionary who died for her beliefs, the other, a middle-class American wife and mother who navigated womanhood in her own way.

Forming the Fifth International belongs to a series of works about Alice's late stage of life. Earlier in her career, Stevens made a series, *Big Daddy*, reflecting on her father's racism, which she wrote about in *Heresies*, in articles such as "Looking Backward in Order to Look Forward: Memories of a Racist Girlhood" (1982), an unflinching account of the insidious nature of racism and the artist's reckoning with it as a child. "At home my father talked against Jews, blacks, Italians, and Catholics in general," Stevens writes. "He had his own internal chart: English, Scots, Scandinavians, Germans, Irish, French, Italians, Jews/Syrians, Blacks."[34] Alice is seen in contrast to Stevens's oppressive father, as influential for the artist in a positive way. She viewed her mother sympathetically as having few choices in life outside of the dominant one of becoming a housewife. Luxemburg and Alice were both heroines for Stevens, but of different kinds, having formed their identities, their selfhoods, around their unique complexities. The artist honors the roles of both women in *Forming the Fifth International*.

Claire Tabouret
The Soccer Team, **2019**
Acrylic on canvas
86 ³/₅ × 118 ¹/₈ inches
Courtesy the Artist and Night Gallery, Los Angeles
© Claire Tabouret
Photo: Marten Elder

Claire Tabouret looks at teams and groups in much of her recent work, including a painting debuting in *Women Painting Women* that is sourced from a photograph of a college-aged Iranian female fencing team. A hallmark of Tabouret's work is using neon underpainting as a base in her large-scale canvases, to which she applies layers of watery acrylic. Neon, for the artist, represents a break from reality and a leap into fantasy. Her groups of figures enter a more cerebral than tangible space due not only to her paint treatment and unusual palette but also because of the postures of her sitters and glances they cast. Sometimes stiff and uncomfortable, other times confident or silly, the group portraits question individuality and how we shape notions of the self based on peers and archetypes. With all the positives that come with being a team player, there is another side that signifies conformity (uniforms, the notion of taking one for the team, being loyal to the values of the group), much like the godmother in Rego's *Bullfighter*. Tabouret points to the longstanding traditions that shape prescribed roles—on a team or of gender—and she nods to the implicit rebellion in women's participation in sports. That the source image for *The Fencers,* 2022, is Iranian adds another layer of collective pressure, given how politics, religion, and revolution can change identity.

With regard to female team imagery, Tabouret is struck by how people stand in a group and how it correlates with power and interpersonal dynamics. "Women generally tend to be more aware of not taking up too much space. I looked at feminist protests and other groups of women who are asking for more space, but still, they hold back from taking up space in the photographs. There's a contradiction about the female body."[35]

Christiane Lyons
*Yayoi: Arrangement in Yellow Lake and
Vermillion Clair*, **2021**
Oil on canvas
58 × 49 inches
Courtesy of the Artist and Meliksetian | Briggs, Los Angeles
© 2022 Christiane Lyons, Courtesy of the Artist and
Meliksetian | Briggs, Los Angeles

Similar to Tabouret's considerations of group behavior—and to her method of translating a photograph into her own vision—Christiane Lyons explores female individuality and objectification, often by merging aspects of art history with pop culture. In *Yayoi: Arrangement in Yellow Lake and Vermillion Clair*, 2021, Lyons uses several appropriated images of different women's bodies, pulling from diverse sources such as fashion photography and social media. She then creates a painting portraying a composite of one woman who is many-sided. The bold patterned dress and dots of colors in the background of *Yayoi* are direct references to the Japanese contemporary artist Yayoi Kusama, for whom the painting is named. Kusama's art-world recognition early in her career—which continues to this day—is unusual given that she is a Japanese woman. Canonically, she is an outlier, not an archetype.

With *Yayoi*, as with much of her work, Lyons creates a painting that, though strikingly cohesive, cannot be visually resolved in that it shows multiple perspectives at once. With one synthesized woman of varying skin tones, from different eras and classes, wearing dissimilar clothes, and who posed in varying ways, the artist suggests the complications of generalizing women, and how doing so does not acknowledge or celebrate individuality. By referring to Kusama, a woman artist who broke through race and gender barriers, Lyons reinforces this idea.

Lyons often titles her works after the person who inspired the portrait and the paint pigments used, as in *Yayoi: Arrangement in Yellow Lake and Vermillion Clair*. These two-part titles reiterate the subject/object dichotomy. "The subject is a female artist who is influential to my practice. And the object is the actual oil colors that figure predominantly into the painting. It is a device employed by the painter James McNeill Whistler, who wished to de-emphasize the narrative content of his work and direct the viewers' attention to the artist's manipulation of paint."[36] Citing art history in these ways, Lyons's work creates a conversation about self in relation to other (subject/object) and is a subversive retrieval of the self by pointing to an image of woman that cannot ultimately be reconciled.

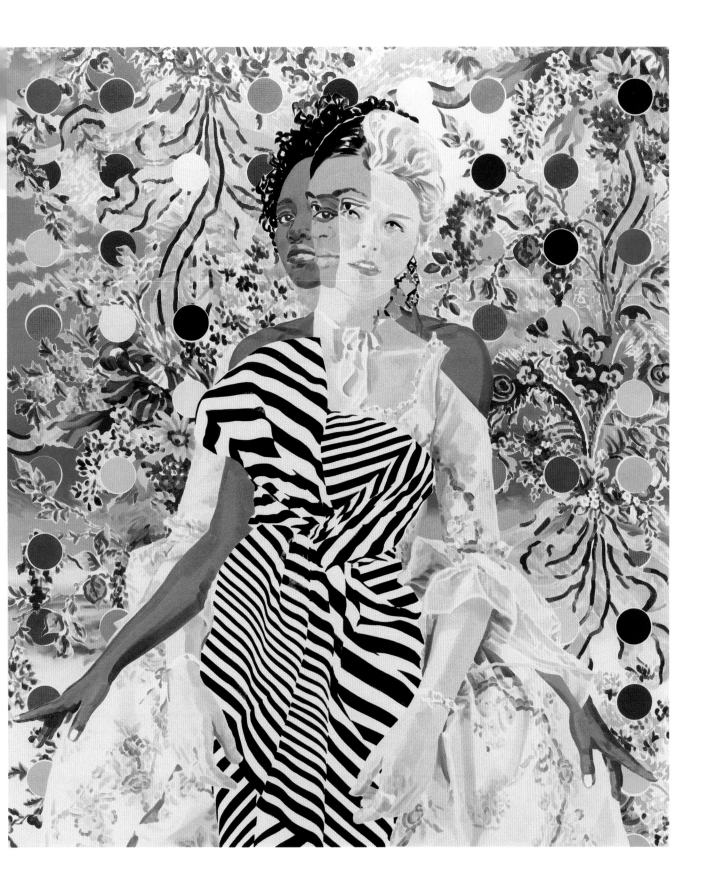

Deborah Roberts
The innocent and the damned, 2021

Mixed-media collage on canvas
72 x 60 inches
© Deborah Roberts, Courtesy the Artist and
Stephen Friedman Gallery, London
Photo: Paul Bardargjy

Deborah Roberts also works with merged figures. A new work, as yet untitled, will debut in the exhibition *Women Painting Women.* In a recent work, *The innocent and the damned,* 2021, she combines collage and paint with mixed media on canvas to address a conceptual/political concern—probing the challenges young Black children confront as they grow up burdened by loaded, preconceived social constructs and surveilled by the white gaze. Through collage, Roberts endows the girl with varying skin tones and features patched together from multiple sources. As in the work of Amos and Lyons, the skin tone differences suggest that not all women are alike, and further, not all women of color are alike. The fusion of girl images ironically operates also as metaphor for individuality both because of each subject's idiosyncrasies and because the soulful eyes of each girl usually return our gaze dead on.

Roberts started her career making images of young girls in what she saw as depictions of Black American culture, a subject largely omitted from art history, but then she read an essay by Cornel West that shook her to the core. It describes the power of the Black body and how it is a taboo topic in white America.[37] Roberts has since depicted young girls and boys in self-protective postures or huddling together. With the conceptual shift that came after reading West, her work subtly raises questions of innocence and vulnerability. Yet in other instances, Roberts's subjects appear casual, confident, and at ease, with their childlike innocence still whole. Notions of beauty, identity, and race surface in these works, with a focus on what Black girls who become women begin to navigate from a young age in contemporary society.

Kim Dingle's depictions of young children also explore the tipping point into loss of innocence. She created *Study for the Last Supper at Fatty's (Wine Bar for Children I)*, 2007, after briefly opening an eatery called Fatty's in her studio, with her partner. The foray into the restaurant industry was all consuming, leaving the artist with little time to paint. She turned to working on small sheets of vellum that eventually formed the scene in *Last Supper*, which depicts raucous, drunken, and passed-out

Kim Dingle
Study for the Last Supper at Fatty's
(Wine Bar for Children I), 2007
Oil on vellum
77 ¼ x 121 ¾ inches
Courtesy of the Artist and Sperone Westwater, New York
© Kim Dingle
Image courtesy Sperone Westwater, New York

girls together at a bar. Their white lace socks and black Mary Janes dangle from the tall stools. The topics of childhood, violence, and race are accessed by Dingle in works that are marked by irreverence. In some ways, as with the work of Dana Schutz (see page 114), comic relief allows the bigger conversation to seep through. Is this what the darling girls aspire to?

Maria Lassnig
Die Junggesellin (The Bachelorette), 2004–05
Oil on canvas
80 × 60 inches
Green Family Art Foundation, courtesy of Adam Green Art Advisory
© 2022 Artists Rights Society (ARS), New York / Bildrecht, Vienna

Maria Lassnig, Marlene Dumas, and Dana Schutz abridge external elements of the body to present us with states of mind and being.

Austrian-born Lassnig moved to New York in the 1960s and became involved with a group of feminist artists. Although her art engaged with feminism, she worked against being typecast. Throughout her career, Lassnig, who died in 2014, explored the female body in what she termed "body awareness" paintings that investigate internal feelings through external acts such as sitting. The physiological states she explored also suggest a mood, or psychological state, as is the case with *Die Junggesellin (The Bachelorette)*, 2004–05. Characteristically for her work, the cartoonish and abstracted figure is human scale and a kind of self-portrait in contrasting colors, often set against a blank background. Also characteristic is the directness of color and form that Lassnig relates to herself in an effort to render unselfconscious depictions that explore sensations normally only felt and not seen. Through these self-portraits, Lassnig ties her anatomy to interiority by painting the parts of her body she most readily felt in the moment. The artist is activated by thoughts, moods, and intuitions in these body awareness works, much like a jolt of adrenaline can be felt in the gut or feelings of love can create an allover tingle.

Marlene Dumas
Jen, 2005
Oil on canvas
43 ⅜ × 51 ¼ inches
The Museum of Modern Art, New York. Gift of Marie-Josée and
Henry R. Kravis in honor of Klaus Biesenbach and Christophe Cherix
© Marlene Dumas
Image courtesy Marlene Dumas
Photo: Peter Cox, Eindhoven

The liveliness of Lassnig's figure is absent from Marlene Dumas's *Jen*, 2005, which depicts the head of a woman who is lying prone, mouth slightly open, and eyes closed. Without any context, the image is ambiguous—the subject could be dead, resting, or in a post-coital moment. Her sallow complexion and blue lips are at odds with her pink and deep-red nipple that, through foreshortening, becomes the dramatic passage in the work, suggesting ecstasy. The image, in fact, comes from Dumas's disturbing series of corpses, in this case borrowed from Yoko Ono's film *Fly*, 1970, in which the corpse is played by an actress lying still. The abject condition of *Jen* explores female objectification and takes the idea to an extreme degree.

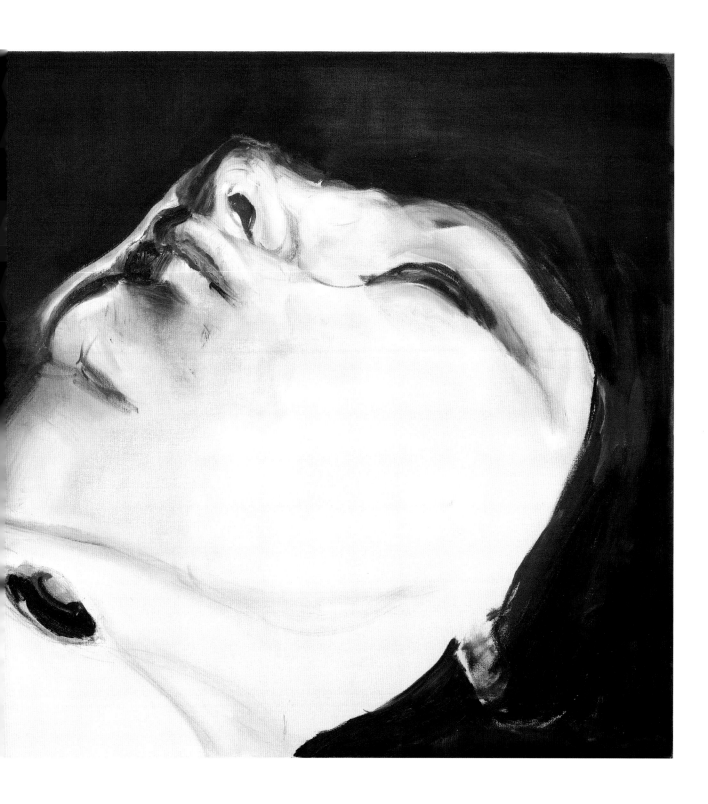

Dana Schutz
Swimming, Smoking, Crying, **2009**

Oil on canvas
45 × 48 inches
Collection Nerman Museum of Contemporary Art,
Johnson County Community College, Overland Park,
Kansas, Gift of Marti and Tony Oppenheimer and the
Oppenheimer Brothers Foundation
© Dana Schutz, Courtesy the Artist and David Zwirner

Dana Schutz's *Swimming, Smoking, Crying*, 2009, suggests a
different state of abjectness—one of self-deprecation. Known for
her thick paint and expressive canvases that are as emotive as
they are absurd and grotesque, Schutz shows us an inner world that
exudes desperation but also simplified and essential humanness.
The woman subject, who is struggling to keep her head above
water, is looking for relief. She pacifies herself by smoking, and
she cries. Schutz has talked about challenging herself to paint a
feeling. This work comes from her 2009 series of verb paintings, in
which she strung together three actions that are impossible to do
simultaneously but perhaps can work in pairs, like swimming and
crying or crying and smoking, but not swimming and smoking.[38] As
odd and impossible as the actions may be in unison, here they are
relatable as both an outer, bodily experience and as an expression
of an interiority that is punctuated with humor and empathy.

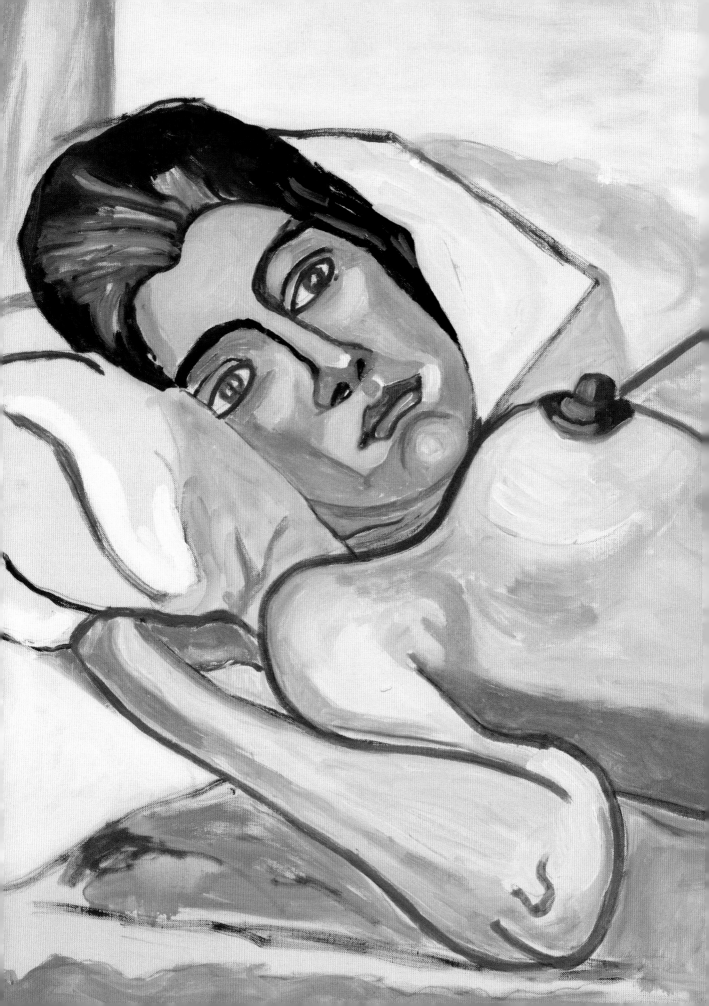

An Open Gaze

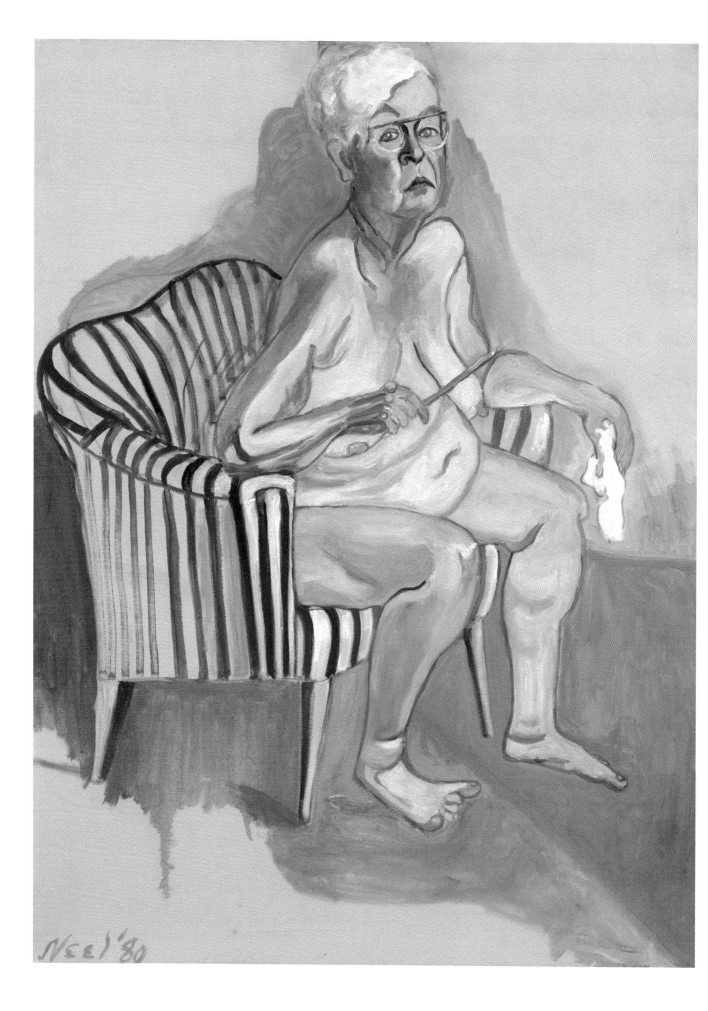

Alice Neel
Alice Neel Self-Portrait, 1980
Oil on canvas
53 ¼ × 39 ¾ inches
National Portrait Gallery, Smithsonian Institution
© The Estate of Alice Neel

Alice Neel was an innovator at all stages of her career. In 1980, at age eighty, she painted her first fully realized self-portrait, now regarded as one of her masterworks. Sitting in a blue-and-white-striped armchair, the artist looks directly out at the viewer, paintbrush in hand, wearing only eyeglasses. This image—her nakedness, her age, her direct stare, her honesty—stuns. Describing the portrait's potency as being about more than Neel's nude body, her biographer Phoebe Hoban writes:

> *Neel has basically turned the notion of the "gaze," whether artist's or viewer's, male or female, inside out. She's the artist depicting herself as subject, no holds barred. She's defied gender stereotypes by deliberately casting the female body as the furthest possibility from a sex object. And she's challenged art history itself, which is studded with famous self-portraits— from Rembrandt's celebrated images of himself as an old man to van Gogh's harrowing self-depictions—by painting one that is sui generis.*[39]

Neel once again radicalized the female portrait—woman painting woman—outdoing even her younger self. She weaponized herself, turning herself into a direct challenge to gender and art-world stereotypes, as Hoban says. And in doing so, she opened up more possibilities for all women painters. It took artists like her, stubbornly wedded to figuration and courageous in choices of subjects— unromanticized pregnant women, couples in awkward moments, herself, aged and nude, and even Andy Warhol, the ultimate voyeur, with his eyes closed—to create a path of inclusivity. Other painters active in the mid-twentieth century, such as Emma Amos, Faith Ringgold, and Sylvia Sleigh, stand out as having equally traversed layers of resistance and many cultural and political complexities to put women artists on the map.

This text owes a great deal to many other exhibitions and writings, including the influential exhibition and catalogue *WACK! Art and the Feminist Revolution,* curated by Cornelia Butler and organized by the Museum of Contemporary Art, Los Angeles, in 2007. The essayists there acknowledge the dangers of pigeon-holing women by grouping them under the feminist umbrella. Butler writes, "It is my contention that—whether unintentionally or lacking the language or cultural context to support a feminist idiom—the artists in this exhibition contributed to the movement and development of feminism in art, if only by reinforcing two central tenets: The personal is political, and all representation is political."[40] *Women Painting Women,* smaller in scope and focused on figuration, offers a similar sentiment in expressing what some artists have done to create forward momentum in investigating women as subjects. The international group of women presented here are some of the most influential artists of the twentieth and twenty-first centuries and are discussed through the flexible themes of Nature Personified, The Body, Color as Portrait, and Selfhood. This survey only glances through the diverse scope of how women see women in painting, and it is meant to celebrate the female image in its many forms.

Endnotes

1 Linda Nochlin, "Why Have There Been No Great Women Artists?" (1971), reprinted in Nochlin, *Women, Art, and Power and Other Essays* (New York: Harper & Row, 1988), 145–78.

2 Nochlin, 150.

3 Laura Mulvey, "Visual Pleasure and Narrative Cinema" (1975), reprinted in Mulvey, *Visual and Other Pleasures* (London: Palgrave Macmillan, 1989), 14–26.

4 bell hooks, "The Oppositional Gaze: Black Female Spectators," in *Black Looks: Race and Representation* (Boston: South End Press, 1992), 116.

5 hooks, 131.

6 Willem de Kooning, quoted in *MoMA Highlights* (New York: The Museum of Modern Art, 2004), 206.

7 Eunice Golden, "The Male Nude in Women's Art: Dialectics of a Feminist Iconography," *Heresies #12: Sex Issue* 3, no. 4 (1981): 40–42.

8 Golden, 42.

9 Joan Semmel, "A Necessary Elaboration," in *Joan Semmel: Across Five Decades* (New York: Alexander Gray Associates, 2015), 5.

10 María Berrío, email to the author, December 13, 2021.

11 Berrío, email.

12 Hayv Kahraman, email to the author, October 20, 2021.

13 Kahraman, email.

14 Marilyn Minter, email to the author, October 13, 2021.

15 Minter, email.

16 Lisa Brice and Aïcha Mehrez, "Q&A: Lisa Brice," *Tate Etc.* 43 (Summer 2018): https://www.tate.org.uk/tate-etc/issue-43-summer-2018/lisa-brice-art-now-interview-aicha-mehrez.

17 *Counter Culture*, episode featuring Natalie Frank in conversation with Kweli Washington, posted May 29, 2015, https://www.youtube.com/watch?v=xEXnclVSLTw.

18 Natalie Frank, email to the author, October 17, 2021.

19 Frank, email.

20 Celeste Dupuy-Spencer, quoted in Katherine Cooper, "Celeste Dupuy-Spencer," *Bomb* 142 (January 9, 2018): https://bombmagazine.org/articles/celeste-dupuy-spencer/.

21 Jenna Gribbon, "Jenna Gribbon on Neon Nipples and Wrestling Women," *Art in America* (October 14, 2019): https://www.artnews.com/art-in-america/interviews/jenna-gribbon-on-neon-nipples-and-wrestling-women-56495/.

22 "Anti-Racist Shakespeare: *A Midsummer Night's Dream*," webinar by Shakespeare's Globe featuring Farah Karim-Cooper, Aldo Billingslea, and Vanessa I, recording posted May 27, 2021, https://www.youtube.com/watch?v=DkMiphOB5UA.

23 "Amy Sherald: In the Studio," Hauser & Wirth, video, posted October 7, 2019, https://www.hauserwirth.com/ursula/26023-amy-sherald-studio.

24 "Amy Sherald: In the Studio."

25 Amy Sherald, email to the author, October 25, 2021.

26 Sherald, email.

27 James Mills, "The Legacy of Arctic Explorer Matthew Henson," *National Geographic*, February 28, 2014, https://www.nationalgeographic.com/adventure/article/the-legacy-of-arctic-explorer-matthew-henson.

28 Arpita Singh, as relayed by her gallerist Deepak Talwar to the author, October 27, 2021.

29 Arpita Singh, quoted in Y. Dalmia, "Arpita Singh: Of Mother Goddesses and Women," in *Expressions & Evocations: Contemporary Women Artists of India*, ed. G. Sinha (Mumbai: Marg Publications, 1996), 72.

30 Louise Bonnet, email to the author, October 22, 2021.

31 Nicole Eisenman, "Painter Nicole Eisenman: 2015 MacArthur Fellow," MacArthur Foundation, video, posted September 28, 2015, https://www.youtube.com/watch?v=390v9Cfi2Lk.

32 "Jordan Casteel Stays in the Moment," *New York Close Up*, art21.org, November 17, 2017, https://art21.org/watch/new-york-close-up/jordan-casteel-stays-in-the-moment/.

33 Maria Manuel Lisboa, "So Sorry for Your Loss," in Lisboa, *Essays on Paula Rego: Smile When You Think about Hell* (Cambridge: Open Book Publishers, 2019), 25–28.

34 May Stevens, "Looking Backward in Order to Look Forward: Memories of a Racist Girlhood," *Heresies #15: Racism Is the Issue* 4, no. 3 (1982): 22.

35 Claire Tabouret, email to the author, October 29, 2021.

36 Christiane Lyons, email to the author, October 22, 2021.

37 Robin Pogrebin, "A Dream Deferred, for Now," *New York Times*, April 13, 2020.

38 Dana Schutz, lecture, School of Visual Arts, New York, recording posted April 18, 2016, https://www.youtube.com/watch?v=hkYyHMvL2n0.

39 Phoebe Hoban, *Alice Neel: The Art of Not Sitting Pretty* (New York: St. Martin's Press, 2010), 333.

40 Cornelia Butler, *WACK! Art and the Feminist Revolution* (Los Angeles: Museum of Contemporary Art; Cambridge, MA, and London: MIT Press, 2007).

"Some Do's and Don'ts
for Black Women Artists,"
by Emma Amos,
first published in *Heresies*
magazine in 1982

SOME DO'S AND DONT'S FOR BLACK WOMEN ARTISTS

BY EMMA AMOS

DON'T admit to being over 28 unless you are over 58. It's handy to be either young and hot, or a doyenne, like Neel or Nevelson. In the middle, it's finding time and space, jobs, kids, lovers, husbands, and hard slogging, no glamour, no news.

DON'T take your art to Soho or 57th Street without Alex Katz's written introduction. Soho/57th Street doesn't dig blackass art. (They do still love "primitive" art, but don't be confused.) I think unsolicited slides are reviewed so the director can continually reinforce decisions about what he or she will NOT show.

DON'T complain about being a black woman artist in the '80s. Many people, both black and white, think you were fashioned to fit the slot in a turnstile—a mere token, baby. They may also think, deep down, that your minority face is a meal ticket entitling you to some special treatment they're not getting. All minorities have this problem; you've just got to tough it out.

DON'T fantasize about winning recognition without breaking your behind for it. There are no "instant winners" in today's art world, the MacDonald Awards not inclusive. (Hope springs eternal.)

DON'T fret about things over which you have little control:
> The landlord raises your rent when you put new wiring in the studio.
> Your work overflows every available space, and even your new $400 flat file is delivered already full.
> The show you're in next month is not insured.
> The show you're in gets reviewed, but the writer went to the John Simon school of criticism and your work gets singled out as too _____.

DO take good slides every 3 months or so. Business in the art world is transacted through transparencies. Art that doesn't look good reduced to 1 x 1 ⅓ probably shouldn't be reproduced. More people may look at your ektachromes than will ever see your work for real.

DO show as often as you can—new work if possible. Discourage curators from selecting work whose ideas you're no longer involved with. It's hard to do, but each show should reveal something more about you, a progression.

DO exhibit with people whose work you like and in which you find similarities to your own. There's nothing intrinsically good about being a loner; finding parallels won't make you a "groupie."

DO be supportive of all your artist friends. Your peers are the people who see your work as it's happening. They give you feedback and keep you going.

DO extend yourself:
> Let the Studio Museum know you're alive.
> Let the Met know you're contemporary.
> Let the Museum of Mod Art know you're permanent.
> It'll probably net you only a "thank you," but we need to let them know how many of us are out there.

DO be thankful and shout "Hallelujah!" for:
> Dealers, agents, and pals who work at JAM.
> Lovers, husbands, children, patrons, and friends.
> Norman Lewis—whose art, elegance and concern impressed so many of us.
> Alma Thomas—she hung on, and it was worth it.
> Nellie Mae Rowe—she keeps working, an incredible Atlanta "folk" artist.
> Norma Morgan—the engravings, the work! Where is she?
> Romare Bearden—bright, open and deserving of all the praise.
> Samella Lewis and Val Spaulding—whose *Black Art Quarterly* is so beautiful.
> Hatch-Billops—the collection you must see, to know what "black art" is.
> Bob Blackburn—the artist's printmaker and shoulder for 25 years plus.
> James Van Der Zee—who has always been an artist.
> Hale Woodruff—who would help any artist, black or white.
> Lena Horne—for her transformation and hard work.
> Tina Turner—who found herself and is free.
> Toni Morrison—who invents and forms worlds.
> Duke Ellington—whose music is our soul.
> Stevie Wonder—he deserves to be taken more seriously.
> Bill Cosby—kills us on Carson, and buys art, too.
> Ntozake Shange—who shows us how to use the system and how to survive success.
> Maya Angelou.
> Katherine Dunham.
> The "do praise" list goes on.

Emma Amos, *Preparing for a Facelift*, 1981. Etching and crayon. 8 ¼ × 7 ¾ inches. © Emma Amos, Courtesy RYAN LEE Gallery, New York

"The 1970s: Is There a Woman's Art?," a chapter from *We Flew over the Bridge: The Memoirs of Faith Ringgold*

In 1970, white women were on TV screaming about "male chauvinist pigs." The women's art movement in New York was just beginning. At the Art Workers' Coalition, some women had created Women Artists in Revolution (WAR) and they asked me to join and come to meetings, but I didn't have the time. I was too busy with Tom Lloyd and MOMA trying to get a wing for black artists, money allocated to buy black artists' works, and black trustees on the museum's board. Trying to get the black man a place in the white art establishment left me no time to consider women's rights. I had thought that my rights came with the black man's. But I was mistaken. Now what was I to do?

I first found out about the Women's Liberation Movement in 1967 from Flo Kennedy, the civil rights lawyer. I had called her to get some names of people to invite to my solo exhibition and she gave me those of Betty Friedan and Ti Grace Atkinson. They were the founding members of the National Organization for Women (NOW). Betty Friedan was the author of a most provocative book entitled *The Feminine Mystique*, which some felt made her the founder of the movement; and Ti Grace Atkinson, a feminist theorist, had been an art director in a Philadelphia museum. Flo suggested that both could be helpful to me, and further that I should arrange to meet them, join NOW, and get involved with the women's movement. I sent them all invitations to my 1967 show and attempted halfheartedly to reach the two women by phone with no success. Flo came to my opening with some women from NOW. They were all women's liberationists and I admired them that night for looking the part. They carried with them propaganda about the movement: notices of meetings, plans for feminist actions—all of which later came to be called "bra burnings" by the media.

It was not until 1970, however, that I got involved in the women's movement. In this year I became a feminist because I wanted to help my daughters, other women, and myself aspire to something more than a place behind a good man. The "Liberated" Biennale, the Whitney demonstrations, and the Flag Show were my first out-from-behind-the-men actions. In the 1960s I had rationalized that we were all fighting for the same issues and why shouldn't the men be in charge? I would be just the brains and the big mouth.

In the 1970s, being black and a feminist was equivalent to being a traitor to the cause of black people. "You seek to divide us," I was told. "Women's Lib is for white women. The black woman is too strong now—she's already liberated." I was constantly challenged: "You want to be liberated—from whom?" But the brothers' rap that was the most double-dealing was the cry that "the black woman's place is behind her man," when frequently white women occupied that position.

In May of 1970, Art Strike was formed out of the AWC. Its purpose, though not stated in quite this way, was to give superstar white male artists a platform for their protests against the war in Cambodia. Robert Morris, then called the "Prince of Peace," had issued an appeal for American artists to withdraw their work from the 1970 Venice Biennale. The purpose of this international exhibition was to display the work of contemporary artists of the "free" (white) world. Each nation chose and sent its own exhibit. In 1970, the Americans selected were Claes Oldenburg, Andy Warhol, Frank Stella, Robert Rauschenberg, Roy Lichtenstein, Jim Dine, and Robert Morris among others—all superstar white male artists.

Organized by Morris, the "Liberated" Venice Biennale was a protest against the war in Cambodia, and more generally against the American government's policies of racism, repression, sexism, and war. This protest exhibition was scheduled to open July 6, 1970, at the School of Visual Arts on West 23rd Street in New York City. I began to fantasize that, since the United States government had not presented in its original Venice selection an unbiased representation of the "fine" art of American artists, then we would now have the chance to rectify their shortsightedness. And, since there was a stated commitment among these powerful superstar white male artists concerning

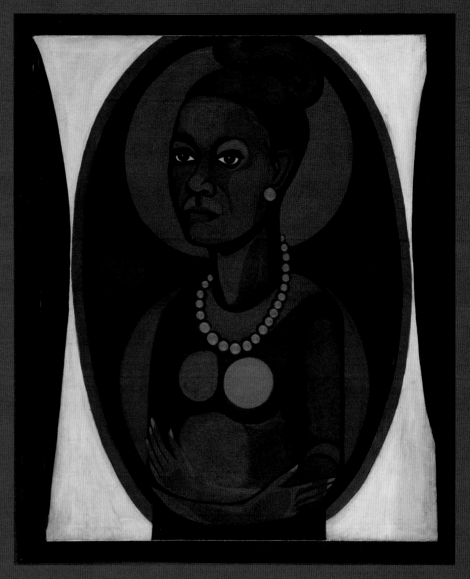

racism and sexism, surely there would be support for a *truly* liberated Venice Biennale. In fact, we could create an "open show," although it soon became sadly clear that that was hardly the intent of the organizers.

When I made this suggestion to the women artists preparing to install the show at the School of Visual Arts, they were aghast. "But there were no women in the original group that withdrew from Venice, and no blacks," they explained to me condescendingly. I explained: "That's because the committee which selected the artists for the Venice Biennale was racist and sexist, and we are not." Well, these women, many of whom had spoken to me at length about feminism and the women's movement, could see nothing politically wrong with presenting the show "as is"— with no women and no blacks. Even though it was the racist and sexist policies of the United States that were being protested, the government's prejudices were still dictating the show.

Art Strike took over the AWC, with Morris and the artist Poppy Johnson in charge. Michele [my daughter] was living at home now, attending City College and going to AWC meetings with me. She and I speedily formed an ad hoc group called Women Students and Artists for Black Art Liberation (WSABAL). We were persistent about liberating the "Liberated" Venice Biennale. We made it clear that WSABAL would demonstrate if the show did not include blacks and women. The white women at the AWC, including most of the WAR women, were against us. They didn't seem to understand the real meaning of the feminism they were espousing. Some "girlfriends" of the superstars were verbally abusive and physically threatening to us. We stood toe-to-toe at meetings in open confrontations. One woman became so irate at the prospect of having women and blacks included in the superstars' show that she screamed, "Don't you understand, we can't have that shit in this show!"

"We will demonstrate and close it down if it is not opened to include women and blacks," we responded forcefully. WSABAL was a small group composed of Tom Lloyd, Michele, and myself together with a couple of students from the School of Visual Arts who regularly attended AWC meetings. (The students had had a longstanding battle at the school over special funding for black students and demands for programs and black teachers.)

When we started to prepare a press release on our position, we needed to decide on how many blacks, women, and students should be included in the show. We wanted to prevent them from merely selecting a few token black male artists. "What percentage of women do you think we should demand to be in the show?" I asked Michele. She looked up from her reading and said abruptly and matter-of-factly, "Fifty percent." I was stunned. I had never heard anyone suggest that much equality for women. She was so young, not yet eighteen, and we had been through so much recently with Mexico and Barbara's tumultuous last year at high school. Maybe she was under a strain, maybe she just hadn't heard me right, or I hadn't heard her right. I asked again, "What percentage for the show . . . I mean of women?" This time I listened more closely. Michele looked up and, raising her voice, looked me dead in the eye. She repeated herself, "Fifty percent women, and fifty percent of those women have to be black and twenty-five percent have to be students." Well, the numbers game began. There were now all kinds of jokes over our percentage demands. The point, however, was made. We were talking here about

real equality. After all, this was the way racism had worked all these years with percentages and quotas. Maybe we could now work it to our advantage.

All hell broke loose just before the show was to open. Brenda Miller, one of the women artists against the revised show, kidnapped the original show and took it to her loft in New York's Westbeth. (There was a secret plan to take the show to Washington, D.C., to open at the Corcoran Gallery, and the arrangements had been made with Walter Hopps, the director of the Corcoran.) But Morris, again in his role as Prince of Peace, got the show back in time for our opening. The liberated Liberated Venice Biennale was open to all who wanted to participate. The exhibition began on July 22, 1970, in the newly painted loft space of "Museum," the meeting place of AWC and Art Strike. The show consisted of more than fifty percent women and included more black artists, students, and political poster artists than any other "Biennale" before or since. However, some of the superstar artists and their dealers felt that the show was fraught with too much confusion and decided to withdraw. They included Claes Oldenburg, Richard Anuszkiewicz, Ernest Trova, Nicholas Krushenick, and Adja Yunkers. The ones remaining were Andy Warhol, Carl Andre, Frank Stella, Robert Rauschenberg, Roy Lichtenstein, Vincent Longo, Leonard Baskin, Jim Dine, Sam Francis, Robert Birmelin, Michael Mazur, Deen Meeker, Sal Romano, and, of course, Bob Morris.

Within a few weeks' time the show ended abruptly. As the story goes, one of the women artists enticed Bobby, the night watchman at Museum, into the back room under the ruse that they were going to make passionate love together—which, if you had known Bobby, you would know how funny that was. After she detained Bobby long enough for her women accomplices to get four works by the show's superstars out of the gallery, she released Bobby, leaving him "high," which he was all the time anyway, and "dry." The paintings were retrieved, again by Morris with the assistance of Carl Andre. They took the works back to Castelli and to the other galleries that had loaned them. The show was over. Security had been broken. And Bobby split.

In the fall of 1970 Poppy Johnson and Lucy Lippard formed an ad hoc women's group to protest the small percentage of women in all past Whitney Annuals. I was asked to join and I agreed. I was excited about the prospect of black women artists being included in the Whitney Annual. Our goal for the 1970 Annual was fifty percent women: Michele's equality percentage for women in the art world had caught on.

The corridors and galleries of the Whitney Museum became the focus of our attention. We went there often to deposit eggs. Unsuspecting male curatorial staff would pick up the eggs and experience the shock of having raw eggs slide down the pants of their fine tailor-made suits. I made hard-boiled eggs, painted them black, and wrote "50 percent" on them in red paint. I didn't want to waste food. They could eat my black eggs. Sanitary napkins followed. These upset the female staff as well as the men. Generally, everywhere the staff went they found loud and clear messages that women artists were on the Whitney's "case."

The Whitney Annual that year was to be a sculpture show. I was not making sculpture yet, and there were only a few black women sculptors in the country who were known. Elizabeth Catlett and Selma Burke were well-known figurative sculptors. Elizabeth Catlett was my all-time favorite but, because of the Whitney's well-known preference for abstract art, Catlett's prospects waned. Selma Burke was eliminated by a false report by one of the curators that she was dead. Instead, Betye Saar and Barbara Chase-Riboud were cited, whose work was more in line with the Whitney's taste. So they were the ones I unconditionally demanded to be in the show. Saar and Chase-Riboud became the first black women to be in the Whitney Annual; more to the point, they were the first black women ever to be exhibited at the Whitney Museum of American Art. The total percentage of women in the Whitney Annual in 1970 was twenty-three percent—as opposed to the previous years' averages of five to ten percent. This was better than ten percent, but it still wasn't fifty.

We decided to demonstrate during the opening to make that point. We had to get our demonstrators inside, since the opening was by invitation only, so we printed fake tickets and distributed them outside the museum on the night of the opening to anyone who wanted to demonstrate. A guard with an ultraviolet detector confiscated over a hundred forged tickets; nevertheless, we got in a lot of people. Once inside, we mingled with the crowd. Museum officials knew something was afoot as rumors began to spread that there was to be a demonstration that night. One of the trustees of the museum who was on our side, for whatever reason, was concerned that we would not be able to round up the women demonstrators, since everyone was all over the place, drinks in hand (the Whitney had free booze in those days), chatting and locating the art of friends (Louise Bourgeois was in the show) or talking to the other exhibiting artists. I assured him that we would be fine, and that everybody would know when and where the demonstration was happening, even though the show was spread out on the museum's three floors. What I didn't tell him was that we planned to blow police whistles to signal the start of our actions.

Although they supplied us with tickets to enter the museum, the white men in the show did not join our demonstration. (There were no black men there I could approach.) However, the fashionable Whitney art-going crowd was eager to witness our action. They had heard of "sit-ins" and now they were going to see one for themselves. At a predetermined time, Lucy Lippard and I began to blow our whistles. The women came toward the center of the main gallery on the second floor. We continued to blow. The people gathered around us and we formed a big circle sitting on the floor. Then we got up and walked around chanting, "Fifty percent women, fifty percent women." We pulled it off. The crowd was sympathetic, and the event satisfied our need to protest. The trustee I had spoken with seemed pleased that it happened.

Throughout the show we demonstrated every weekend, blowing our police whistles and singing off-key. Barbara and Michele, who were with me at these demonstrations, had suggested that we sing off-key intentionally. However astute their own ears (they are both musical, probably a talent inherited from Earl), intentional off-key singing was bearable to them, and natural to most of us. Barbara made up catchy tunes on the spot, and everybody joined in. "The Whitney is a helluva place, parlez-vous. The Whitney is a hellavu place, parlez-vous. They're down on women and they're down on race, a honky donkey, parlez-vous." Flo Kennedy joined our line one Saturday and was quite at home, singing off-key and making music with police whistles.

The women artists' movement in New York was on its way. There was now a plethora of panels and statements being made concerning women's art and culture. Artists and other folk, both male and female, were beginning to demand explanations of the women's art movement. "Is there a women's art, and if so, what is it?" was the constant question posed to us. The concept of making female images as opposed to male, and black images as opposed to white or abstract, was the crux of the issue. "Who needs all this talk about black art and women's art?" some artists would say. "I'm just an artist who happens to be black or a woman." It was a real challenge to try to define oneself and one's art outside the narrow parameters of the mainstream art world. But we were doing this and it felt good.

Lorna Simpson
Black Darkness, **2019**
Ink and acrylic on gessoed fiberglass
Unique
108 × 96 inches
Collection of the Modern Art Museum of Fort Worth,
The Friends of Art Endowment Fund
© Lorna Simpson, Courtesy the Artist and Hauser & Wirth
Photo: James Wang

We Have Been Whispering in Each Other's Ears For Centuries

Lorna Simpson
June 4th, 2020
Los Angeles, CA

We have been whispering in
each other's ears for centuries.

There is meaning. There is
meaning in the patterns
and activity of birds in flight
hawks mean one thing and
crows and doves mean another.

You are incredibly observant
of everything and all details.

Our awareness is photographic
and remembers everything.

As we were out walking on the
street many details are echoed
back to us by a familiar stranger
on a stoop - has seen me before
but not you, and yet and still
knows everything about us and
tells us so loudly.

We look back at each other in
amazement - that the look of love
can crack open time and space and
reflect back to us - knowing it can
be ripped from us at any moment
leaving a mournful emptiness and
deep anger.

When along I see glimpses of you in
the posture, smile and laughter a
half a block away in someone who
has just turned their head.

Sometimes ghostly sometimes not.
A long time ago in passing I got
to nod and give a smile to my twin
in Mauritania I got a smile and a
nod back.

I know how I loved you before
to the moon and back and over
to Jupiter for a while.

We rescued each other from many
places and did not abandon love.
Migrating was for the brave the
young the old and those who
were hunted.

No time to speak about why and
how come. Generationally, if you
were not there you didn't need to
know for your own good.

Last night moonlight poured onto
the floor luminously and we wake
this morning being ready without
saying a word to each other that
we will defend it all again fiercely.

Artists' Biographies

–Rita Ackermann

Born 1968, Budapest, Hungary
Lives and works in New York City

Rita Ackermann grew up in Hungary. Coincident
with the fall of communism in that country in 1989,
she enrolled at the Hungarian University of Fine Arts
in Budapest, where she remained until 1992. She
then moved to New York, studying at the New York
Studio School for a year. Her first solo exhibition took
place at the Andrea Rosen Gallery in New York in
1994, and in 1998 she had her first solo show in her
native country, at Bartok 32 Galeria in Budapest.
She participated in the Whitney Biennial in 2008.
Experimentation defines Ackermann's work. Her
gestural canvases, most often depicting women,
play with scale and material, representation
and abstraction, and creation and destruction.
Ackermann's figures oscillate between presence
and absence.

Njideka Akunyili Crosby

After moving from Nigeria to the United States, Njideka Akunyili Crosby graduated with a BA from Swarthmore College, studied at the Pennsylvania Academy of the Fine Arts, and in 2011 earned an MFA from the Yale School of Art. Her first solo exhibition took place concurrently at Art + Practice and the Hammer Museum in Los Angeles in 2013, and in 2019 her work was included in the Venice Biennale. She received a MacArthur Foundation Fellowship in 2017. Akunyili Crosby's large, colorful paintings depict intimate, often domestic, moments. The artist's mother often appears in her canvases, as does the artist herself, though she does not consider the works self-portraits. Close inspection reveals a variety of materials, such as fabric and colored pencil, and personal photos and images from US and Nigerian culture woven into the compositions. Drawing on influences that range from the nineteenth-century Post-Impressionist Édouard Vuillard's genre scenes to the photo transfer techniques of the twentieth-century Conceptual artist Robert Rauschenberg, Akunyili Crosby evokes the layers of personal experiences and social determinants that make up the self.

Born 1983, Enugu, Nigeria
Lives and works in Los Angeles

Courtesy the Artist, Victoria Miro, and David Zwirner
Photo: Shaughn and John

Emma Amos

Born 1937, Atlanta, Georgia
Died 2020, Bedford, New Hampshire
Lived and worked in New York City

Emma Amos at the Art Salon Show, 1979
Photo: Robert Levine

Emma Amos grew up in the segregated American South, raised by college-educated parents whose fathers had been born into slavery. She completed a BA at Antioch University in Ohio in 1958, had her first solo exhibition at the Alexander Gallery, Atlanta, in 1960, and graduated with an MA in art education from NYU in 1965. During her six decades as a painter, printmaker, weaver, activist, and teacher, Amos created an influential body of work examining issues of gender and race inequalities. She was active in the Guerrilla Girls, a group of artists who anonymously agitated to reduce art-world bias and corruption. In 2004, she received the Women's Caucus for Art Lifetime Achievement Award. Her paintings of figures incorporate combinations of textiles, photographs, and prints that draw in multiple forms of knowledge and experience. Amid the abundance, composition and color reflect the turbulent social forces affecting the artist's subjects. Amos considered her art a form of resistance and hoped that it would dislodge prejudices and provoke more considered ways of thinking and seeing. In 2021 and 2022, the Georgia Museum of Art, Munson-Williams-Proctor Arts Institute, and Philadelphia Museum of Art hosted the first major retrospective of her work.

María Berrío —

Born 1982, Bogotá, Colombia
Lives and works in Brooklyn

María Berrío covers large canvases with layers of Japanese paper to create works that encompass human connections to nature and to each other, as well as her experiences as an immigrant and an independent woman. When young, Berrío left the political instability of her native Colombia and moved to the United States with her family. Her family later returned to South America, but Berrío remained in New York to pursue a career as an artist. She completed her BFA in 2004 at the Parsons School of Design and her MFA in 2007 at the School of Visual Arts. Praxis International Gallery hosted her first solo exhibition, in 2012, and in 2021, the Norton Simon Museum of Art in West Palm Beach organized a survey of her work. Idealized, otherworldly figures, almost always female, populate her compositions, occupying seductively beautiful, surreal spaces, some of which derive from South American folk tales. Although Berrío's protagonists seem suspended, waiting rather than taking action, details in the settings and in the works' titles reveal their compassion and courage as they face the turmoil around them.

–Louise Bonnet–

Born 1970, Geneva, Switzerland
Lives and works in Los Angeles

Photo: Jeff McLane. Courtesy Gagosian

Louise Bonnet imbues her paintings with surreal drama as mutant figures, often female but sometimes genderless, engage in curious activities. She studied illustration and graphic design at the Haute école d'art et de design in Geneva. A 1994 visit to Los Angeles became a permanent relocation, and in 2008 she had her first solo exhibition at LA's Subliminal Projects gallery. In 2013, seeking to better capture light, Bonnet started teaching herself to work with oil paint. Her compositions blend the grotesque and abject with humor. Bodies with shrunken or inflated heads, limbs, and gender signifiers occupy spaces governed by contorted scale. As the protagonists undertake peculiar actions with unclear motivations, the image teases the subconscious. Crucially, hair or other impediments block the protagonists' eyes; as a result, the subjects neither confront viewers nor perform for them, giving the observer permission to play the voyeur.

Lisa Brice —

Born 1968, Cape Town, South Africa
Lives and works in London and Trinidad

Photo: Adam Davies, 2017

Lisa Brice grew up in South Africa during the apartheid era. She graduated from the fine art school at the University of Cape Town in 1990 and had her first solo exhibition in 1993 at the Galerie Frank Hänel, Frankfurt. Although she moved to London five years later, experiences in South Africa continue to inform her paintings, as do the history and culture of Trinidad, where Brice held a residency in 2000. The artist describes her painting process as similar to printmaking: she accumulates ideas and uses drawing exercises to unify the material. Brice often starts her female nudes by looking at a portrait by a male artist. To that composition, Brice may add accoutrements such as cigarettes and booze and accents of strong reds or blues. The resulting paintings evidence the subjects' lineage as objectified beings, but they also clearly assert the women's present autonomy. Nevertheless, uncertainty and ambiguity persist, as recurring motifs of mirrors and doorways in Brice's compositions suggest passages, transitions, ruminations, and illusions.

Joan Brown

Born 1938, San Francisco, California
Died 1990, Puttaparthi, India
Lived and worked in Northern California

Joan Brown was a member of the second-generation Bay Area Figurative movement. She and artist Henrietta Berk (1919–1990) were the only two women ever associated with the genre. In the 1970s, Brown abandoned the gestural brushwork that defined the style and embraced the smooth sheen of enamel paint. Her compositions, often self-portraits, reflect her personal life, extensive travels, and explorations of non-Western cultures and spirituality. Brown graduated from the California School of Fine Arts (now the San Francisco Art Institute) with a BFA in 1959 and an MFA in 1960. In 1986, she received an honorary doctorate from the school. Her first solo exhibition took place at the Six Gallery in San Francisco in 1957. The Berkeley Art Museum hosted a mid-career retrospective of her work in 1974, and that same year she joined the faculty of the department of art at the University of California, Berkeley. In 1977, she participated in the Whitney Biennial. During the 1980s, she completed several public art commissions, which she considered a more democratic form of art than canvases sold through a gallery. Tragically, Brown died in an accident while installing a work at a museum in India.

Jordan Casteel —

Born 1989, Denver, Colorado
Lives and works in New York City

Courtesy the Artist. Photo: David Schulze

Jordan Casteel grew up surrounded by her family's art collection, which included works by Faith Ringgold and Romare Bearden. She graduated with a BA in studio art from Agnes Scott College in Decatur, Georgia, in 2011. She completed an MFA at the Yale School of Art in 2014 and had a solo exhibition three years later at the Harvey B. Gantt Center for African-American Arts + Culture in Charlotte, North Carolina. Casteel seeks to create honest evocations of the complex identities of the men and women she depicts. Working from photographs of the sitters in their customary spaces, such as their homes, their places of business, or on the New York City subway, the artist lets her intuition guide the process of translating the figures and landscapes to canvas. With gestural brushwork and bold color, the portraits become an extension of herself. In 2021, Casteel was awarded a MacArthur Foundation Fellowship.

—Somaya Critchlow—

Born 1993, London, United Kingdom
Lives and works in London

Image courtesy Somaya Critchlow, Blau International, and
Maximillian William, London. Photo: Lewis Ronald

The British artist Somaya Critchlow earned her BA
in fine art painting at the University of Brighton in
2016. She completed a postgraduate diploma at
the Royal Drawing School in 2017, and her first solo
exhibition in the United Kingdom was organized
in 2020 by Maximillian William, London. Reacting
to the absence of people who look like her in the
art historical canon and fascinated by questions
of self-perception and otherness, Critchlow depicts
Black women in works that simultaneously deploy
and subvert traditions of portraiture. Her paintings
reflect diverse influences in their examinations of the
figure, nudity, and atmosphere. Critchlow's canvases
critique expectations of race, sex, and power. Their
often diminutive scale refers to the portrait miniature,
an artform designed for private enjoyment, or even
fetish; but the sitters' confidence emphatically rejects
possession by another.

Kim Dingle —

Born 1951, Pomona, California
Lives and works in Los Angeles

Kim Dingle began making sculptures and paintings of mischievous little girls shortly after she received her BA in art from California State University, Los Angeles, and her MFA from Claremont University Center. She had her first solo exhibition featuring the troublesome tots at the Richard/Bennett Gallery in Los Angeles in 1991. The youngsters' cuteness contrasts with their violent activities, a juxtaposition that reflects the artist's childhood experiences and serves as a satiric metaphor for American culture. The fluid nature of knowledge subtly permeates Dingle's oeuvre. In one series, she worked while blindfolded and, in another, re-created maps from memory. She often paints on vellum, a durable material that lends a velvety texture to paint and evokes ancient manuscripts. Dingle participated in the 2000 Whitney Biennial. She then stopped making art for nearly a decade, an unintended consequence of converting her studio into a restaurant, which she named Fatty's & Co. after a recurring character in her compositions. When the operation was sold in 2013, recollections of the experience became material for new paintings.

—Marlene Dumas—

Born 1953, Cape Town, South Africa
Lives and works in Amsterdam

Marlene Dumas grew up under apartheid on a vineyard near Cape Town, South Africa. She received her BA in fine arts from Cape Town University in 1975 and moved to the Netherlands to study art and psychology. Her first solo exhibition took place in 1979 at the Galerie Annemarie de Kruijff, Paris, and in 1982 she was one of the youngest artists invited to show at Documenta 7. The Dutch Pavilion at the 1995 Venice Biennale spotlighted her work, and she participated in the Biennale again in 2003, 2005, and 2015. Although she focused on drawing, collage, and other works on paper early in her career, she turned to paint as her primary medium in the mid-1980s. Unsentimental photography, perhaps overexposed or distorted, and cinematic techniques like the zoom and close-up inform her compositions, which lack the accoutrements and accessories typical of portraits. The complexities of human relationships, love, and sexuality, as much as the sitters themselves, constitute the subjects of Dumas's canvases.

Celeste Dupuy-Spencer

Celeste Dupuy-Spencer grew up in New York's Hudson Valley and earned a BA in 2007 from Bard College, where she studied with Nicole Eisenman. In 2014, Dupuy-Spencer settled in Los Angeles, where she had her first solo exhibition at Artist Curated Projects in 2015. She has participated in the Whitney Biennial and in group shows at the Hammer Museum in Los Angeles and the Museo Tamayo Arte Contemporáneo in Mexico City, among others. Dupuy-Spencer identifies as queer and transgender but, as part of her rejection of the binary and its hierarchies, without a pronoun preference. The artist counts the Mannerists of the Renaissance among her early influences, along with Alice Neel and Egon Schiele, and, later, Kerry James Marshall and Henry Taylor. Her work embraces the tension and ambiguity of liminal spaces, such as those between the personal and the archetypal, the intimate and the political, resentment and dignity, and repression and love.

Born 1979, New York, New York
Lives and works in Los Angeles

Image courtesy of Nino Mier Gallery and the Artist
Photo: Dawn Blackman

—Nicole Eisenman—

Born 1965, Verdun, France
Lives and works in Brooklyn

Courtesy Nicole Eisenman

Nicole Eisenman grew up in Scarsdale, New York, following their family's move from France in 1970. Eisenman graduated in 1987 with a BFA from the Rhode Island School of Design and immediately moved to New York City. Their first solo exhibition took place in 1992 at the Shoshana Wayne Gallery in Santa Monica, and three years later they participated in the Whitney Biennial (and again in 2012 and 2019). The artist works from life, drawings, photos, or pure imagination for their figurative oil paintings, which refer to styles and themes from art history, sometimes citing specific works. Their canvases deploy allegory, satire, and incisive humor to explore social dynamics such as gender and sexuality, family life, and power, while vivid color intensifies the emotional content of the composition. In 2005, Eisenman co-founded Ridykeulous, a curatorial project focused on queer and feminist art. The Contemporary Art Museum St. Louis organized a mid-career retrospective in 2014, which traveled to Philadelphia and San Diego. The artist received a MacArthur Foundation Fellowship in 2015, was inducted into the American Academy of Arts and Letters in 2018, and exhibited in the Venice Biennale in 2019.

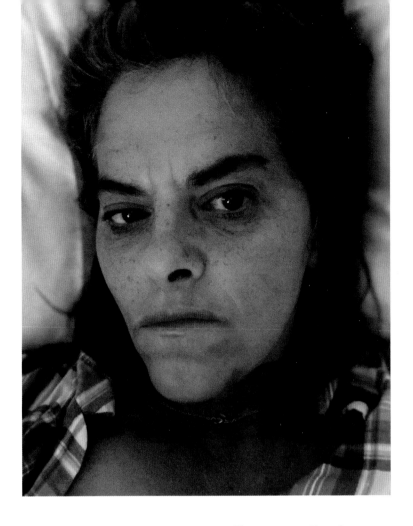

Tracey Emin —

The art of Tracey Emin, CBE, RA, unflinchingly reflects her life experiences, including suffering abuse from the age of eight, being raped at thirteen, and having had multiple abortions. She graduated in 1986 from Maidstone College of Art in Kent, England, with a BA in fine art and went on to earn an MA in 1989 from the Royal College of Art. Her first solo exhibition took place four years later at London's White Cube gallery, and in 1997, Emin participated in the controversial *Sensation* exhibition of works by a group that came to be called the Young British Artists. Using her body as a model along with her personal history, Emin explicitly depicts sexuality and emotional complexity in paintings, drawings, sculptures, videos, and installation art. Scrawls reminiscent of graffiti cover her canvases as images appear then transform into abstractions, seem complete then become illegible. The artist represented Britain at the 2007 Venice Biennale, and in 2011 the Hayward Gallery in London held a mid-career retrospective of her work. That year, Emin also became professor of drawing at the Royal Academy of Art, the first woman to hold that position in the Academy's 243-year history.

Born 1963, London, United Kingdom
Lives and works in London

Self-portrait by the artist, November 2021. © The Artist

─Natalie Frank─

Born 1980, Austin, Texas
Lives and works in Brooklyn

Photo: Daniel Kunitz

Natalie Frank depicts strong women in complex situations that are often sexually charged and violent. She earned a BA in art in 2002 from Yale University, where she met her mentor, Paula Rego, studied at the Oslo National Academy of the Arts on a Fulbright Scholarship, and completed her MFA in Visual Arts at Columbia University in 2006. That year, her first solo exhibition took place at Briggs Robinson Gallery, New York. The Madison Museum of Contemporary Art in Wisconsin and the Kemper Museum of Art in Kansas City, Missouri, hosted a survey of her drawings in 2021 and 2022. Frank, who is also a writer, uses layering and fragmentation to explore themes of boundaries and transformation, critiquing narratives of female vulnerability such as fairytales, erotic literature, and discussions of sex work. She fills her large canvases with detours and dissonances that evoke uncertainty and instability. The theatricality of her work is not limited to the canvas: Frank's depictions of *Grimms' Fairy Tales* inspired a Ballet Austin production, and she collaborated on *A Jarful of Bees*, a film opera exploring memory and relationships, with the composer Paola Prestini.

Hope Gangloff —

Born 1974, Amityville, New York
Lives and works in Brooklyn

Photo: Don Stahl

While growing up in Amityville, New York, Hope Gangloff made murals and other sizeable works in her parents' barn. She earned a BFA at Cooper Union in 1997 and spent several years working in foundries in Montana and New York before returning to painting in the 2000s. Gangloff invests her large-scale figures, landscapes, and still lifes with vibrant color and line. For her portraits, which are usually of women, she insists on depicting people she knows, arguing that familiarity puts both the sitter and the artist at ease. She and her models collaborate on the settings, often a domestic scene or a painted backdrop the model may have helped create, but above all, the atmosphere is relaxed. The artist's brushwork and attention to detail transform prosaic moments in ordinary places into poetic renderings of the sitter's essence. Gangloff had her first solo exhibition in 2006 at Susan Inglett Gallery.

Eunice Golden

Born 1927, New York, New York
Lives and works in New York City

Eunice Golden participates in the exhibition *Contemporary Crafts*, The Museum at Guild Hall of East Hampton, New York, 1991–92. Photo: © 1991 Walter Weissman

When in 1973 the renowned feminist art historian Linda Nochlin designed a class on the male nude in art, the groundbreaking syllabus included Eunice Golden along with Alice Neel and Sylvia Sleigh. Golden began to explore the male nude as subject matter in the 1960s, despite the drapery that cloaked male models' genitals at Art Students League classes. While other women artists declared their power through portrayals of the female body and genitalia, Golden asserted the female right to direct the gaze toward the male. Excluded from exhibitions and museum collections because of the challenging subject matter of her paintings, in 1971 Golden joined the Ad Hoc Women Artists' Committee, which staged demonstrations demanding representation of women in museums and galleries; and in 1973 she was a founding member of SOHO 20, a gallery dedicated to promoting women artists. In 1978, Golden earned her BA in Fine Arts from SUNY, Empire State College, and she received her MFA from Brooklyn College in 1980. Golden approaches both male and female bodies as landscapes—emphatically not portraits—capturing a powerful yet vulnerable eroticism and offering a rejoinder to centuries of female nudes as mythological and allegorical beings.

Jenna Gribbon

Jenna Gribbon majored in painting at the University of Georgia before earning an MFA from Hunter College in New York City. Three years after moving to New York in 2003, she had her first solo exhibition at the Sarah Bowen Gallery in Brooklyn. Her figurative paintings investigate queerness and capture moments intimate and public, spontaneous and staged, dramatic and humorous, often taking her son or her girlfriend as their subjects. Gribbon destabilizes scenes with unexpected compositional choices. Poses from seventeenth-century Dutch paintings might coexist with settings from her childhood in Tennessee and contemporary logos. These juxtapositions, along with unconventional framing and colors, prompt the viewer to reconsider where they are looking and why. While Gribbon draws from art history and personal experiences for her work, her canvases also reflect the influence of the camera phone and its wordless documentation and online sharing of small moments and personal narratives.

Born 1978, Knoxville, Tennessee
Lives and works in Brooklyn

Photo: Nir Arieli, Courtesy of the Artist

—Alex Heilbron——————————————

Born 1987, San Rafael, California
Lives and works in Los Angeles

In 2008, Alex Heilbron's first solo exhibition took place at the Klimm Gallery in San Francisco. She graduated the following year with a BFA from the San Francisco Art Institute, studied at the Kunstakademie Düsseldorf from 2014 to 2017, and completed her MFA at the University of California, Los Angeles, in 2020. Heilbron's canvases merge the modernist grid with patterns based on early-twentieth-century textile designs. As silhouettes of young women with ponytails weave among the layers of color and line, bodies appear and recede, reflecting the multitude of transitions involved in womanhood. Rather than taming the patterns' energy, the grid further activates it. Abstraction and figuration compete for attention, and the bodies become the most stable element of the compositions.

Ania Hobson

Born 1990, Wyre Forest, United Kingdom
Lives and works in Suffolk

Although primarily known for portraits, Ania Hobson did not learn to paint from life until 2014, while studying at the Florence Academy of Art. She received her BA in fine art from Ipswich University in Suffolk in 2011 and took classes at the Royal Drawing School in London in 2013. Her first solo exhibition took place two years later at the Aldeburgh Gallery, on the southeast coast of England, and in 2019 she participated in the Venice Biennale. She works from a minimum of preliminary sketches in order to approach the canvas with a high degree of spontaneity. The artist cites as inspiration Alice Neel's style, Kerry James Marshall's compositional strategies and use of color, and Lucian Freud's painterly representations of skin tone. Hobson's depictions of women downplay gender signifiers to focus on the body as an architectural element within the space it occupies.

Luchita Hurtado

Born 1920, Maiquetía, Venezuela
Died 2020, Santa Monica, California
Lived and worked in Santa Monica and
Arroyo Seco, New Mexico

Luchita Hurtado, 2020. © The Estate of Luchita Hurtado.
Courtesy The Estate of Luchita Hurtado and Hauser & Wirth.
Photo: Fredrik Nilsen

For decades, Luchita Hurtado worked on her paintings only at night while her family slept. She immigrated to New York from Venezuela with her mother in the late 1920s and later studied at the Art Students League. During the 1940s, Hurtado traveled frequently to Mexico City, gaining exposure to new mediums and styles such as Mexican muralism. She moved to Los Angeles in 1951 and built a second home near Taos in 1970. Hurtado experimented with medium and style throughout her career, and her body became a favorite model, viewed from a perspective no one else shared and often situated in landscapes and interiors as a sign of connection with place. The Woman's Building in Los Angeles hosted one of her early solo exhibitions in 1974; her next solo exhibition did not occur until four decades later, in 2016, at Park View Gallery in Los Angeles. The show made such an impression that just three years later the Serpentine Sackler Gallery, London, mounted a retrospective, which traveled to the Los Angeles County Museum of Art in 2020.

Chantal Joffe —

Chantal Joffe, RA, lives and works in London. She completed a BA in fine art at the Glasgow School of Art in 1991 and an MA at the Royal College of Art in 1994. Two years later, she participated in Britain's annual exhibition dedicated to emerging artists, *New Contemporaries*, and in 1999, her first solo exhibition took place at Il Capricorno Gallery in Venice. Although she studied alongside some of the group known as Young British Artists, Joffe pursued figuration rather than the conceptualism of the YBAs. She appropriates images, almost always of female subjects, and renders them in fluid paint that subtly distorts and, in doing so, invigorates the forms. The artist based early paintings on pornography, later exploring fashion photographs and, most recently, self-portraiture and candid depictions of motherhood. Whether her canvases measure ten inches or ten feet, Joffe aims not for realism but for brutal honesty. Recently, in the kind of public commission rarely awarded to women artists, Joffe created a large-scale work for London's new Whitechapel train station.

Born 1969, Saint Albans City, Vermont
Lives and works in London

Photo: Isabelle Young

—Hayv Kahraman—

Born 1981, Baghdad, Iraq
Lives and works in Los Angeles

In 1992, Hayv Kahraman and her family fled Baghdad
to escape the Gulf War and found asylum in Sweden.
She studied graphic design in Florence, Italy, and at the
University of Umeå, Sweden, before moving to the United
States in 2006 and eventually settling in Los Angeles. Her
first solo exhibition took place in 2007 at Celebrating
Women in the Arts in Diyarbakir, Turkey. The recurring
woman that inhabits her paintings, with pale skin, dark
hair, prominent eyebrows, and bright lips, emerged
while the artist was in Florence. The figure combines
Kahraman's own features with Renaissance portrait
conventions and manifests the artist's early connections
to Mesopotamian history and her later assimilation
into Western culture. She paints shallow compositions,
inspired by Japanese woodcuts and eleventh-century
manuscripts, on bare linen that recalls the color of Iraqi
sand, imbuing the body with energy and movement.
Her recurrent, unhesitating depictions of contortion,
disfigurement, violence, and sexuality reflect the struggles
of countless displaced women, past and present, from
every geography.

Maria Lassnig —

Trained in academic realism at the Academy of Fine Arts Vienna during World War II, Maria Lassnig experimented with abstraction before deciding to make the human figure central to her colorful, expressive compositions. In 1948, she coined the term "body awareness" to describe how she painted self-portraits: depicting only those body parts she actively sensed while working (as a consequence, she rarely painted her hair). The idea connected figuration with Abstract Expressionism's emphasis on autographic gesture. Also in 1948, Galerie Kleinmayr in Klagenfurt, Austria, hosted Lassnig's first solo exhibition. In 1960, she moved to Paris, and in 1968 to New York City, where she became interested in animation and made several short films. As her influence and reputation grew, Lassnig returned to Vienna in 1980 to become the first female professor of painting in any German-speaking country, at the University of Applied Arts Vienna. Numerous museums have held retrospective exhibitions of Lassnig's work, including the Centre Pompidou (1996), MoMA PS1 (2014), and the National Gallery Prague (2018). Shortly before her death, she received a Golden Lion for lifetime achievement at the 55th Venice Biennale.

Born 1919, Kappel am Krappfeld, Austria
Died 2014, Vienna, Austria
Lived and worked in New York City and Vienna

Maria Lassnig, March 2002. Photo: © Bettina Flitner

—Christiane Lyons—

Born 1980, San Francisco, California
Lives and works in Los Angeles and San Francisco

Christiane Lyons earned her BA in Art Practice in 2000 from the University of California, Berkeley, where her professors included the art historian T. J. Clark, and her MFA four years later from the University of California, Los Angeles. One of her earliest solo exhibitions took place at Gallery 3209 in Los Angeles in 2011. Following graduate school, she worked for the Conceptual artist John Baldessari for several years, and his methods have heavily influenced Lyons's approach to painting. Like her mentor, she often appropriates images and collages them into new compositions. Her preferred source is social media, particularly fashion photographs. She manipulates and recombines female bodies, clothing, backgrounds, and other details into paintings with dazzling amounts of visual information. Unable to resolve Lyons's creations into singular figures, viewers find themselves facing fundamental questions, such as how images influence our understanding of the world, how painting conveys meaning, and how parts make—or fail to make—a whole.

Danielle Mckinney —

Danielle Mckinney earned her BFA in photography and related media from the Atlanta College of Art in 2004 and her MFA in photography from Parsons School of Design in 2013. Although Mckinney painted for many years, she primarily showed photography until 2021, when Fortnight Institute held the first solo exhibition of her paintings. The artist applies her training in photography to her works on canvas. She begins with a dark ground and lets the image emerge from it, not unlike the process of developing film. Tight cropping and contrasts between light and dark recall photographic compositions. Mckinney examines sources such as old photographs and paintings, movies, and social media, seeking to understand how they convey mood. These observations shape her figures, often quasi-self-portraits, with lone, fashionably dressed Black women in stylish interiors, lost in introspection. An unapologetic smoker, Mckinney includes cigarettes as a recurring motif in her paintings, arguing that the gesture of smoking intensifies contemplative moments, both in real life and on the canvas.

Born 1981, Montgomery, Alabama
Lives and works in Jersey City, New Jersey

Courtesy of the Artist. © Danielle Mckinney

—Marilyn Minter—

Born 1948, Shreveport, Louisiana
Lives and works in New York City

Photo: Nadya Wasylko, 2014

The photographer, painter, and videographer Marilyn Minter completed her BFA in 1970 at the University of Florida, Gainesville, and her MFA two years later at Syracuse University. Her first solo exhibition took place in 1975 at the Everson Museum of Art in Syracuse. Minter's photorealist paintings explore what she calls the "pathology" of glamour, appropriating treatments of the female body from traditional portraits, popular culture, and the pornography industry. She often assembles multiple photographs into a single composition from which she paints, typically in enamel on metal. The resulting high-finish painting, with selective details blurred, restores the sitter's agency. Often excluded from exhibitions during her early career because of her frank treatment of female sexuality, Minter participated in the 2006 Whitney Biennial and the 2011 Venice Biennale and was the subject of a retrospective in 2015 that traveled to Houston, Denver, Orange County, and Brooklyn. In 2021, the School of Visual Arts in New York awarded Minter an honorary doctorate.

Courtesy The Estate of Alice Neel and David Zwirner
Photo: Sam Brody 1943

Alice Neel —

Alice Neel's career spanned six decades during which her chosen genre, portraiture, fell out of favor and was partly resurrected. She graduated from the Philadelphia School of Design for Women (now Moore College of Art and Design) in 1925. For nearly a decade starting in the mid-1930s, she worked for the Works Progress Administration and its successors. Her first solo exhibition in the United States took place in 1938 at Contemporary Arts in New York. After difficult years during the 1940s and 1950s, she began to receive recognition in the 1960s and 1970s as a pioneering female artist, and in 1979 she was one of the first recipients of a Women's Caucus for Art Lifetime Achievement Award. Neel preferred to paint from life or memory rather than photographs because she enjoyed interacting with her sitters and could capture expressive details. Her forthright and sometimes humorous portraits of family, friends, colleagues, activists, and others often depict neglected subjects, such as her marginalized neighbors in Spanish Harlem, frank appraisals of male and female sexuality, and the realities of pregnancy and motherhood. Since the Whitney Museum held the first retrospective of her work in 1974, Neel has been the subject of numerous retrospectives in the US and Europe.

Born 1900, Merion Square, Pennsylvania
Died 1984, New York, New York
Lived and worked in New York City

Elizabeth Peyton

Born 1965, Danbury, Connecticut
Lives and works in New York City

Elizabeth Peyton's work documents the overlap between the profoundly personal and the universal, from the emotions invoked by the music of German composer Richard Wagner or American rock musician Kurt Cobain to our understanding of environmental activist Greta Thunberg's journey across the Atlantic. The artist seeks to capture the immediacy of experience by distilling the magic ignited by creative magnetism, love, or connected purpose. Peyton earned her BFA in 1987 from the School of Visual Arts in New York. Her work first attracted public attention in 1993 after an exhibition of her historical portraits took place in Room 828 at the Chelsea Hotel. In 2004, she participated in the Whitney Biennial, and in 2008 a mid-career retrospective traveled to New York, Minneapolis, London, and Maastricht. A 2017 Villa Medici exhibition created a dialogue between Peyton's portraiture and that of sculptor Camille Claudel, born a century earlier. London's National Portrait Gallery held a major survey of Peyton's work in 2019–20, which traveled to Beijing in 2020.

Paula Rego —

Born 1935, Lisbon, Portugal
Lives and works in London

Paula Rego, DBE, RA, has worked in a variety of mediums, including oil, pastel, prints, and collage; and a range of styles, starting with surrealism and abstraction during her early years and later turning to figuration. She takes her subject matter from sources as varied as folk tales and personal experiences, art history and politics. Rego's protagonists overcome challenging situations, revising conventional narratives of women's power and agency. The artist left Portugal in 1951 for the UK, where she studied at the Slade School of Fine Art in London until 1956. After returning to Portugal, she had her first solo exhibition in 1965 at the Sociedade Nacional de Belas Artes in Lisbon, and in 1969 she represented Portugal at the XI Bienal de São Paulo in Brazil. In 1974, in the aftermath of the Portuguese revolution, she moved back to London and her career continued to flourish. Calouste Gulbenkian Foundation in Lisbon mounted the first of many retrospectives of Rego's career in 1988. She has received numerous honorary doctorates and, in 2004, Portugal's Grã-Cruz da Ordem de Sant'lago da Espada. A museum dedicated to her work opened in 2009 near Lisbon.

—Faith Ringgold—

Born 1930, New York, New York
Lives and works in New Jersey

Photo: Grace Matthews, 1993

Faith Ringgold's career as a painter, sculptor, performance artist, writer, teacher, and activist began when she was a child, surrounded by the energy of the Harlem Renaissance. She studied visual art at the City College of New York and received her BS in 1955 and MA in 1959. The civil rights movement inspired her first major series of paintings, *American People*, which formed the core of her first solo exhibition, in 1967 at the Spectrum Gallery in New York. In 1970, Ringgold helped found the Ad Hoc Women Artists' Committee, which protested the absence of art by women in museum collections and exhibitions. In addition to politics and personal history, Ringgold's work makes reference to African and European art and a Tibetan Buddhist fabric painting practice called thangka. The under-appreciated art of quilting became a hallmark of her work starting in 1980, when she collaborated with her mother to add quilting to a composition. In 1994, she received a Women's Caucus for Art Lifetime Achievement Award. A major retrospective of Ringgold's work took place at the Serpentine Gallery in London in 2019. Now Professor Emeritus of Art at the University of California San Diego, Ringgold has received twenty-three honorary doctorates in recognition of her contributions.

Deborah Roberts —

Deborah Roberts grew up in a working-class family that considered art a hobby, not a profession. Nevertheless, in 1985 she graduated with a BFA from the University of North Texas. Shortly afterward, she founded an arts program for teenagers and opened a gallery in Austin, Texas. Recognition arrived slowly, and her first solo exhibition did not take place until 2004 at the Center for African and African American Studies in Austin. In the early 2000s, reading bell hooks and Cornel West led Roberts in new directions, and she pursued an MFA at Syracuse University, graduating in 2014. Roberts works primarily in collage, assembling found images of Black people into portraits of African American child- and young adulthood. In the process, she grants her subjects agency missing from mass-media depictions. Roberts also embeds her work with symbols drawn from art history, American culture, and Black experience. Her collages resonate with the process of building identity in the face of restrictive social constructs.

Born 1962, Austin, Texas
Lives and works in Austin

Photo: Moyo Oyelola. Courtesy the Artist
and Stephen Friedman Gallery, London

Photo: Koos Breukel © 2021
The Estate of Susan Rothenberg / Artists Rights Society (ARS),
courtesy Sperone Westwater, New York

—Susan Rothenberg—

Born 1945, Buffalo, New York
Died 2020, Galisteo, New Mexico
Lived and worked in New Mexico

When Susan Rothenberg moved to New York City in 1969, newly graduated with a BFA from Cornell University, she was making abstract Color Field paintings. A doodle led her to figuration, and these canvases featured in her first solo exhibition, at 112 Greene Street in New York in 1975. Four years later (and again in 1983 and 1985), she participated in the Whitney Biennial, and in 1980 and 2007, the Venice Biennale. Rothenberg's compositions, often circular or radial, explore the relationship between the subject and the surface of the painting, reflecting the motion studies of the nineteenth-century photographer Eadweard Muybridge, as well as the fragmentation of Cubism and the visual energy of Futurism. In 1989, Rothenberg moved to Galisteo, New Mexico, with her husband and fellow artist Bruce Nauman. Experiences and observations in the desert landscape inspired new imagery and broadened her palette. The Albright-Knox Art Gallery in 1992 organized a mid-career retrospective that traveled to five US cities. Another retrospective took place in 2009–11, visiting three US cities.

Jenny Saville —

Jenny Saville, RA, rejects the idealized classical nude in favor of capturing the realities of normal, naked female bodies, painting them at large scale and from unconventional perspectives. She received her BA in fine art from Glasgow School of Art in 1992 and participated in the Saatchi Gallery's *Young British Artists III* exhibition two years later. In 2021, a mid-career retrospective juxtaposing Saville's canvases with well-known Italian Renaissance works extended across five museums in Florence. Her nudes pointedly address so-called "imperfections." To develop her approach, she observed ordinary people, watched plastic surgeries, visited the morgue, studied anatomy, and researched medical pathologies. Her work reflects careful study of depictions of the body in different cultures and time periods and an appreciation for paintings by Diego Velázquez, Chaïm Soutine, and Willem de Kooning. Pushing the conventions of the genre, Saville's portraits foreground the uncomfortable effects of violence, trauma, and disease.

Born 1970, Cambridge, United Kingdom
Lives and works in Oxford

Photo: A. Saville. Courtesy the Artist and Gagosian

– Dana Schutz –

Born 1976, Livonia, Michigan
Lives and works in Brooklyn

Dana Schutz in her studio, 2021. Photo: Jason Schmidt

Dana Schutz creates new worlds through her art. The narratives that find their way onto her canvases feature absurd hypothetical situations, scathing political commentary, and formless everyday events, such as sneezing. Schutz earned her BFA from the Cleveland Institute of Art in 2000, followed by an MFA from Columbia University in 2002. The same year, she had her first solo exhibition at LFL Gallery in New York, and in 2003 she participated in the Venice Biennale. In 2017, Schutz was included in the Whitney Biennial, and The Institute of Contemporary Art Boston hosted a mid-career retrospective of her work. Schutz uses vibrant pigments, heavy paint application, and forceful brushstrokes. Extruded paint takes on the role of bodily fluid or prominent proboscis, lending her work physical presence that balances its energetic content and color. German Expressionism informs her palette and composition, as do the conventions of twentieth-century cartoons. For the narratives, she looks to sources including history, personal experiences, memories, American culture, music, and television shows. The combination of humor and dark abjection leaves the viewer laughing and crying, not unlike some of Schutz's protagonists.

Joan Semmel is a painter, writer, feminist, and
Professor Emeritus of Painting at Rutgers University.
She graduated from the Pratt Institute with a BFA in
1963, lived in Madrid until 1970, and earned an MFA
at Pratt in 1972. Her first solo exhibition took place in
1966 at the Ateneo de Madrid. Experiences in Spain,
such as needing a husband's or father's signature to
lease an apartment, prompted Semmel to become
involved in feminist causes when she returned to the
United States. Uncomfortable with prevailing ideas of
feminist art, however, with their focus on collaborative
projects and women's labor, she embraced
figurative painting. Her own nude body became
her primary subject, and her canvases reflect her
unfiltered gaze onto its quirks and imperfections,
rendering authentic representations of womanhood
without vanity. Semmel found herself excluded
from exhibitions for many years as a result of her
idiosyncratic approach, but in 2013 the Women's
Caucus for Art recognized her with a Lifetime
Achievement Award, and in 2021 the Pennsylvania
Academy of the Fine Arts held a major retrospective
of her work.

Born 1932, New York, New York
Lives and works in New York City

Photo: Erica Lansner

—Amy Sherald—

Born 1973, Columbus, Georgia
Lives and works in the
Greater New York City area

Photo: JJ Geiger

Amy Sherald paints aspects of Black American life with large-scale portraits in a simplified realist style. Early experiences navigating racism in the American South influenced her choice of subject matter and compositional strategies, particularly her decision to depict complexions in grayscale. The grisaille faces and bodies in her canvases underscore the racial charge associated with skin tone. Staging long photography sessions so her sitters become accustomed to the process and settle into a natural pose, the artist incorporates signals, such as denim or picket fences, to reinforce her sitters' place in American culture. Sherald switched from pre-med studies to earn a BA in art in 1997 from Clark Atlanta University. She completed an MFA in 2004 at the Maryland Institute College of Art (MICA), where Grace Hartigan was among her professors. The Robert and Sallie Brown Gallery and Museum in Chapel Hill hosted the artist's first solo exhibition in 2011. Sherald painted First Lady Michelle Obama's official portrait in 2018, and in 2021 she received an honorary doctorate from MICA.

Lorna Simpson

Born 1960, Brooklyn, New York
Lives and works in Brooklyn

© Lorna Simpson. Courtesy the Artist and
Hauser & Wirth. Photo: James Wang

Lorna Simpson challenges historical and popular
representations of racial and sexual identity, particularly
of Black women, through conceptual photography,
collage, illustration, painting, and video. The artist
received her BFA in photography from the School of
Visual Arts, New York, followed by an MFA from the
University of California San Diego, where one of her
classmates was fellow artist Carrie Mae Weems. She
had her first solo exhibition at the 5th Street Market
Alternative Art Gallery in San Diego in 1985. In 1990,
she participated in the Venice Biennale for the first time
(returning in 2013), and the next year she was in her first
Whitney Biennial (returning in 1993, 1995, and 2002). In
2002, she also showed at Documenta 11. Recognizing the
questionable objectivity of documentary photographs,
Simpson began to create conceptual work, often
appropriating Associated Press (AP) photographs and
images from vintage magazines. Her compositions
frequently show figures from behind or in fragments and
crop or obscure hands and heads, critiquing not only the
depersonalization of Black bodies but also the redacting
of Black narratives.

Arpita Singh

Born 1937, Baranagar, West Bengal, India
Lives and works in New Delhi

Photo: RL Fine Arts, © RL Fine Arts 2019

Arpita Singh grew up near Kolkata and moved with her family to New Delhi in 1946, one year before her country's independence from the UK and the upheavals of partition into India and Pakistan. She earned a Diploma in Fine Arts from Delhi Polytechnic College in 1959, but she did not have her first solo exhibition until 1972, at the Kunika Chemould Art Centre in New Delhi. She has since been recognized as part of India's second wave of modernists, and in 2019 the Kiran Nadar Museum of Art in New Delhi held the first retrospective of her work. Early in her career, Singh learned kantha, a traditional Bengali embroidery technique that builds intricate patterns from tiny stitches. This, along with other Indian folk and traditional arts, continues to influence her painting methods and compositions. Women often play a leading role in her canvases and works on paper, with protagonists situated in dreamlike spaces replete with references to history and mythology. At the same time, Singh embeds astute observations on the chaos and pressures of modern life in a society undergoing rapid change.

Sylvia Sleigh —

Sylvia Sleigh grew up in the United Kingdom and from 1934 to 1937 studied at the Brighton School of Art, which at the time permitted only female nudes in life drawing classes, no males. She worked for several years as a seamstress, and her love of fashion and textiles carried through to her painting career. Always a figurative artist, during the 1940s and 1950s she created numerous still lifes, landscapes, and portraits, and in 1953 had her first solo exhibition, at the Kensington Art Gallery in London. After moving to New York in 1961, Sleigh began appropriating the poses of idealized female nudes from the art-historical canon for canvases populated with male and female nudes. However, instead of romanticizing her subjects, she treated them as authentic humans, with tan lines, body hair, and other imperfections. She was active in the Ad Hoc Women Artists' Committee, which worked to increase representation of women in museum exhibitions and collections, and was a founding member of the all-women, artist-run SOHO 20 Gallery. In 2011, Sleigh was posthumously recognized with a Women's Caucus for Art Lifetime Achievement Award, and the following year museums in Switzerland, Norway, France, Spain, and the UK organized a comprehensive retrospective of her work.

Born 1916, Llandudno, Wales, United Kingdom
Died 2010, New York, New York
Lived and worked in New York City

Sylvia Sleigh at the opening of
WACK! Art and the Feminist Revolution, Museum of
Contemporary Art, Los Angeles, 2007

—Apolonia Sokol—

Born 1988, Paris, France
Lives and works in Paris

At the age of 16, too young to enroll, Apolonia Sokol became a regular visitor to the Düsseldorf Academy of Art. A decade later, in 2015, she graduated with an MFA from the École nationale supérieure des Beaux-Arts in Paris. The next year, she had her first solo exhibition, at Whitcher Projects in Los Angeles. After a fire destroyed much of her work, she began anew and focused on portraiture. In a nod to the erasure she had experienced, she simplified and even eliminated background in her compositions. The open areas of the canvas endured when, she said, she realized that they could also represent her sitters' private, interior spaces. While some of Sokol's paintings draw directly from art history, she attempts to deconstruct power relations by challenging traditional depictions of the nude or semi-nude female. Her portraits of women encompass all races, body types, gender identities, and sexual orientations. They are nude without being sexualized, projecting both mystery and familiarity, fragility and strength.

— May Stevens —

May Stevens maintained that art plays a crucial role in social change. Throughout her long career, her output reflected political struggles such as civil rights, anti-war activism, and female empowerment. Although she earned her BFA from the Massachusetts School of Art in 1946, nearly twenty years passed before she had her first solo exhibition, in 1963, at the Roko Gallery in New York City. Stevens based the works in that show, *Freedom Riders*, on mass-media images of civil rights activists, and Martin Luther King Jr. contributed to the catalogue. Her next series rebuked the Vietnam War, and another cycle of work celebrated women artists. Stevens taught at New York's School of Visual Arts from 1961 until 1996, then settled in Santa Fe in 1997. She was a founding member of SOHO 20, an artist-run gallery focused on increasing opportunities for women; and in 1985, she helped found the Guerrilla Girls, an anonymous group of artists dedicated to calling out bias and corruption in the art world. The Women's Caucus for Art honored her with a Lifetime Achievement Award in 1990, and the Museum of Fine Arts, Boston, held a major retrospective of Stevens's work in 1999, its first for a living female artist.

Born 1924, Boston, Massachusetts
Died 2019, Santa Fe, New Mexico
Lived and worked in Santa Fe

May Stevens in her Soho studio with *The Artist's Studio (After Courbet)*, 1974. Photo: Joyce Ravid

–Claire Tabouret

Born 1981, Pertuis, France
Lives and works in Los Angeles

Photo: Amanda Charchian,
Image courtesy of the Artist and Perrotin

History, mythology, and personal experience form the backbone of every painting by Claire Tabouret. She fleshes out the specific characters on the canvas using photographs she has taken or found in magazines or photo archives as initial source material. Tabouret received her BFA in 2006 from the École nationale supérieure des Beaux-Arts in Paris. Her first solo exhibition took place at the Château de la Louvière in Montluçon, France, in 2008, and in 2015, she moved to Los Angeles. Two years later, she and Yoko Ono presented *One Day I Broke A Mirror* at the Villa Medici in Rome, only the second exhibition dedicated to women artists in the institution's 200-year history. Building on the vocabulary of the Impressionists that she studied as a child, Tabouret assembles tableaux of women, men, girls, and boys replete with theatrical postures, gestures, and costumes. Although she respects the traditional framing and poses of portraiture, her sitters' ambiguous expressions confront the viewer, the tension amplified by Tabouret's palette of earth tones made unnatural with an underpainting of bright artificial hues like fluorescent orange.

Mickalene Thomas —

Mickalene Thomas works in a wide range of media, including painting, collage, photography, video, installation, and performance art. She explores the many ways in which past and present images of the female body affect ideas of identity, gender, and subjectivity to offer a more complex representation of femininity, sexuality, desire, and power. The artist received her BFA from the Pratt Institute in 2000 and her MFA from Yale University in 2002; four years later, her first solo show took place at the Rhona Hoffman Gallery in Chicago. Thomas has received numerous prizes, grants, and fellowships. Taking inspiration from artists like Faith Ringgold and Carrie Mae Weems, Thomas focuses on the experiences of Black women, constructing portraits, landscapes, and interiors that subvert Western art historical notions of beauty and fuse abstraction and figuration, object and subject, real and imaginary. In 2021, Thomas co-founded Pratt>FORWARD, an incubator for post-graduate students. She currently serves on the Board of Trustees for the Brooklyn Museum and MoMA PS1.

Born 1971, Camden, New Jersey
Lives and works in New York

–Nicola Tyson

Born 1960, London, United Kingdom
Lives and works in upstate New York

Insect and animal forms from the natural world that Nicola Tyson explored as a child still find their way into her investigations of female subjectivity. Tyson studied at the Chelsea School of Art (now the Chelsea College of Arts) and St. Martin's School of Art (now Central Saint Martins) in the 1980s, where she felt that women encountered needless obstacles to exercising their creative authority. She relocated to New York in 1989 and had her first solo exhibition in 1993, at Trial BALLOON, a space she established to show work by female, especially lesbian, artists. Rebellious and uninspired by observing and drawing other people from life, Tyson turned to her own body as subject. Her paintings begin as quick, intimate sketches, simultaneously a personal journal and a way to circumvent rational thought—a practice she calls "where consciousness enters matter." She works more deliberately as she transitions her surreal, often humorous, and typically androgynous figures, reflections of bodily experience, into brightly colored paint on canvas.

Lisa Yuskavage

Born 1962, Philadelphia, Pennsylvania
Lives and works in New York City

Lisa Yuskavage graduated from the Tyler School of Art with a BFA in 1984 and from the Yale School of Art with an MFA in 1986. Four years later, Pamela Auchincloss Gallery in New York hosted the artist's first solo exhibition. In 2000, Yuskavage participated in the Whitney Biennial, and she was the subject of a mid-career retrospective in 2020 at the Aspen Art Museum, which traveled to the Baltimore Museum of Art in 2021. Yuskavage satirizes traditional depictions of the female nude in lushly colored canvases populated by doll-like figures in suggestive poses, their breasts and genitalia bizarrely exaggerated. The scenes blend soft porn with art-historical treatments of female bodies, interrogating the demarcation between the two genres. The artist often begins by making models of the figures, staging them to establish space and lighting, and photographing the arrangement to put distance between her and the tableau. Yuskavage disarms the figures' extravagant sexuality with introspective expressions that point to the complicated psychology of female eroticism.

Works in the Exhibition

Rita Ackermann
Get a Job, 1993
Acrylic on canvas
48 × 60 inches
Jennifer and Jon Weaver
Pages 44–45

Njideka Akunyili Crosby
Dwell: Me, We, 2017
Acrylic, transfers, colored pencil, charcoal, and collage on paper
96 × 124 inches
Collection of the Modern Art Museum of Fort Worth, Gift of the Director's Council and Museum purchase, The Benjamin J. Tillar Memorial Trust, 2019
Page 13 (detail) and pages 94–95

Emma Amos
Three Figures, 1966
Oil on canvas
60 × 50 inches
The John and Susan Horseman Collection
Page 67

Emma Amos
Woman with Flower Pot, 1968
Oil on canvas
50 ½ × 44 ½ inches
Doree Friedman
Page 96

María Berrío
Wildflowers, 2017
Mixed media
96 × 140 inches
Nancy A. Nasher and David J. Haemisegger Collection
Title page (detail) and pages 30–31

María Berrío
Clouded Infinity, 2020
Mixed media
84 x 120 inches
Private Collection
Not illustrated

Louise Bonnet
Red Interior with Seated Figure, 2021
Oil on linen
84 × 144 inches
Steven Riskey and Barton Fassino
Pages 84–85

Lisa Brice
Untitled, 2020
Synthetic tempera and gouache on canvas
79 ½ × 38 ¼ inches
Green Family Art Foundation, courtesy of Adam Green Art Advisory
Page 50

Joan Brown
Self-Portrait with Fish and Cat, 1970
Oil enamel on fiberboard
97 ¾ × 49 ¾ inches
Crystal Bridges Museum of American Art, Bentonville, Arkansas, 2015.20
Not illustrated

Jordan Casteel
Pretty in Pink, 2019
Oil on canvas
45 × 30 inches
Collection of the Artist
Page 97

Somaya Critchlow
Grandaddy Clock, 2018
Oil on linen
8 ¼ × 6 inches
Collection Claude Reich
Not illustrated

Somaya Critchlow
Untitled (Rope and Moon), 2018
Oil on linen
8 ¼ x 5 ⅞ inches
The Charles Collection
Not illustrated

Somaya Critchlow
Figure Holding a Little Teacup, 2019
Oil on linen
8 ⅜ × 5 ⅞ inches
Laura & Barry Townsley, London
Page 48

Somaya Critchlow
Kim's Blue Hair with Dog, 2019
Oil on canvas
9 × 6 ⅝ inches
Alvaro Jimenez Collection, London
Page 48

Somaya Critchlow
Untitled (Pink Hair), 2019
Oil on linen
10 × 8 ¼ inches
Isabella Wolfson Townsley, London
Page 49

Somaya Critchlow
The Pool (Blue Surroundings), 2020
Oil on linen
8 ½ x 6 ⅛ inches
Private Collection, Los Angeles
Not illustrated

Somaya Critchlow
The Wait of Silence II (Afternoon Tea), 2020
Oil on linen
20 × 14 inches
Green Family Art Foundation, courtesy of Adam Green Art Advisory
Page 48

Kim Dingle
Study for the Last Supper at Fatty's (Wine Bar for Children I), 2007
Oil on vellum
77 ¼ × 121 ¾ inches
Courtesy of the Artist and Sperone Westwater, New York
Pages 108–09

Marlene Dumas
Jen, 2005
Oil on canvas
43 ⅜ × 51 ¼ inches
The Museum of Modern Art, New York; Gift of Marie-Josée and Henry R. Kravis in honor of Klaus Biesenbach and Christophe Cherix
Pages 112–13

Celeste Dupuy-Spencer
Sarah, 2017
Oil on linen
65 × 50 inches
Collection of Dean Valentine and Amy Adelson
Page 59

Nicole Eisenman
Close to the Edge, 2015
Oil on canvas
82 x 65 inches
Private Collection, Courtesy of Acquavella Galleries
Page 88

Nicole Eisenman
Morning Studio, 2016
Oil on canvas
66 x 83 inches
Hort Family Collection
Not illustrated

Tracey Emin
But you never wanted me, 2018
Acrylic on canvas
71 ⅞ × 71 ⅞ inches
Collection of Gina and Stuart Peterson
Page 16 (detail) and page 28

Natalie Frank
Couple I, 2021
Mixed media
168 × 288 inches
Natalie Frank
Page 34 (detail) and pages 52–53

Hope Gangloff
Queen Jane Approximately, 2011
Acrylic on canvas
66 × 108 inches
Collection of Alturas Foundation, San Antonio, Texas
Page 10 (detail) and pages 72–73

Eunice Golden
Crucifixion #1, 1969
Oil on canvas
48 × 72 inches
Collection of Eunice Golden
Pages 20–21

Jenna Gribbon
Weenie Roast Wrestlers, 2019
Oil on linen
60 × 42 inches
Private Collection, Germany
Page 61

Alex Heilbron
Labor of Thought, 2019
Acrylic on canvas
72 × 54 inches
Collection of Gloria and Howard Resin, Los Angeles
Page 76

Ania Hobson
Two Girls in a Bar, 2020
Oil on canvas
49 ¼ × 57 inches
Green Family Art Foundation, courtesy of Adam Green Art Advisory
Pages 78–79

Luchita Hurtado
Untitled, 1970
Oil on canvas
30 × 50 inches
Courtesy The Estate of Luchita Hurtado and Hauser & Wirth
Pages 24–25

Luchita Hurtado
Untitled, c. 1970s
Oil on canvas
23 ⅞ × 34 ¾ inches
Courtesy The Estate of Luchita Hurtado and Hauser & Wirth
Detail page 18

Chantal Joffe
Self-Portrait Naked with My Mother II, 2020
Oil on board
95 ⅝ × 71 ½ inches
Private Collection
Page 39

Hayv Kahraman
The Tower, 2019
Oil on linen
104 × 79 inches
The Rachofsky Collection
Page 33

Maria Lassnig
Die Junggesellin (The Bachelorette), 2004–05
Oil on canvas
80 × 60 inches
Green Family Art Foundation, courtesy of Adam Green Art Advisory
Page 110

This catalogue is published on the occasion of the exhibition *Women Painting Women*, curated by Andrea Karnes and organized by the Modern Art Museum of Fort Worth, on view May 15 to September 25, 2022.

"Some Do's and Don'ts for Black Women Artists"
© Emma Amos, Courtesy of RYAN LEE
Originally published in *Heresies #15: Racism Is the Issue* 4, no. 3 (1982): 17.

"The 1970s: Is There a Woman's Art?"
© 2022 Faith Ringgold / Artists Rights Society (ARS), New York, Courtesy ACA Galleries, New York
Originally published in Faith Ringgold, *We Flew over the Bridge: The Memoirs of Faith Ringgold* (Durham, NC: Duke University Press, 2005), 174–81.

"We Have Been Whispering in Each Other's Ears for Centuries"
© Lorna Simpson

Published in 2022 by the Modern Art Museum of Fort Worth and DelMonico Books•D.A.P.

Modern Art Museum of Fort Worth
3200 Darnell Street
Fort Worth, TX 76107
817.738.9215
1.866.824.5566 toll free
www.themodern.org

DelMonico Books
ARTBOOK | D.A.P.
75 Broad Street, Suite 630
New York, NY 10004
artbook.com
delmonicobooks.com

ISBN 978-1-63681-035-5
Library of Congress Control Number: 2022931034
Printed and bound in USA

Edited by Leslie Murrell, with S. Janelle Montgomery, Livia Tenzer, and Karen Wilkin
Designed by Derrick Saunders

Front cover: Amy Sherald
A Midsummer Afternoon Dream, 2020
Oil on canvas
106 × 101 inches
Private Collection
© Amy Sherald, Courtesy the Artist and Hauser & Wirth
Photo: Joseph Hyde

Title page: María Berrío
Wildflowers, 2017 (detail)
Mixed media
96 × 140 inches
Nancy A. Nasher and David J. Haemiseggar Collection
© María Berrío, Courtesy the Artist and Victoria Miro

Table of contents: Deborah Roberts
The innocent and the damned, 2021 (detail)
Mixed media collage on canvas
72 × 60 inches
© Deborah Roberts, Courtesy the Artist and Stephen Friedman Gallery, London
Photo: Paul Bardargjy

Texas Commission on the Arts

FORT WORTH TOURISM PUBLIC IMPROVEMENT DISTRICT

ALTURAS FOUNDATION

Lead exhibition support for *Women Painting Women* is generously provided by the Texas Commission on the Arts. Major support is provided by the Fort Worth Tourism Public Improvement District, with additional support from the Alturas Foundation, the Fort Worth Promotion and Development Fund, and RL Fine Arts.